DIGITAL QUICK GUIDE™

D1230763

DIGITAL TECHNIQUES FOR SUCCESSFUL NATURE PHOTOGRAPHY

Cub Kahn

AMHERST MEDIA, INC. ▪ BUFFALO, NY

Dedication

This book is dedicated to the memory of Larry Hanson and Rick Read, who loved learning, teaching, and rambling in wild places. All the trails I walk are brightened by the sparkle that lived in their eyes.

> I will arise and go now, for always night and day
> I hear lake water lapping with low sounds by the shore;
> While I stand on the roadway, or on the pavements gray,
> I hear it in the deep heart's core.
> —W. B. Yeats

> The butterfly counts not months but moments, and has time enough.
> —R. Tagore

Acknowledgments

I thank Craig Alesse, Michelle Perkins, and the staff at Amherst Media for their excellent work in the creation of this book. I thank Jill for her love and support every day. —C. K.

Copyright © 2006 by Cub Kahn.
All photographs by the author.
All rights reserved.

Published by:
Amherst Media, Inc.
P.O. Box 586
Buffalo, N.Y. 14226
Fax: 716-874-4508
www.AmherstMedia.com

Publisher: Craig Alesse
Senior Editor/Production Manager: Michelle Perkins
Assistant Editor: Barbara A. Lynch-Johnt

ISBN:1-58428-184-7
Library of Congress Card Catalog Number: 2005937365

Printed in Korea.
10 9 8 7 6 5 4 3 2 1

TABLE OF CONTENTS

INTRODUCTION

Digital imaging has come a very long way in a short time. A mere 15 years ago, Kodak introduced a 1.3-megapixel digital camera with a $30,000 price tag! This revolutionary "portable" digital system—with its batteries, display, and external hard drive—weighed 55 pounds. Today you can buy an excellent 5-megapixel digital camera for less than 1 percent of that price, and it weighs only a quarter pound.

The recent advancements in digital cameras are among the most profound and rapid technological changes in the 160-plus years since the invention of photography. When you go outdoors to create images of nature with your digital camera, you are part of a technological revolution that gives you ever-

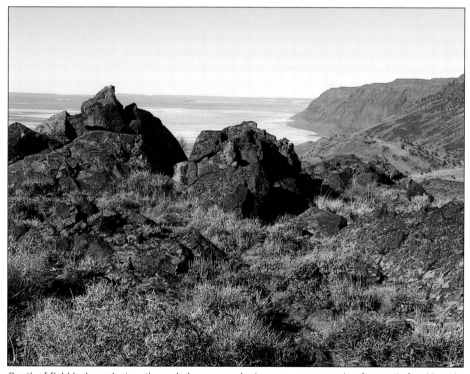

Depth of field is dependent on three choices you make (or your camera makes for you!): focal length, aperture and focusing distance. When you photograph landscapes, if you use a focal length shorter than 50mm, and you focus well back into the scene, you will produce images with a great deal of depth of field. To learn more about depth of field, read lessons 13 and 14. ($^1\!/_{320}$ second @ f/8, 45mm)

increasing potential to produce great nature photos, and to share them with your friends and with the world.

Whether you have a simple point & shoot or a high-end digital camera, if you like to photograph nature and if you want to take better pictures, this book is for you. This is particularly true if you are at a basic or beginner's level with your photography, or if you are in search of a bit of a refresher course.

You may be frustrated because you feel that a lot of your photos do not quite do justice to the beauty you see in nature. Or maybe your frustration lies with the seemingly incomprehensible array of controls and icons you see on your camera. Or maybe you had success with film cameras, but your digital images seem more inconsistent. You know how to turn on your digital camera, zoom the lens, take a picture, review the picture, and send a bad picture to the trash, but you'd like to know more. You'd like to be more confident that when you see wildlife, a landscape, or a flower that catches your eye, you could produce a memorable image to share.

Congratulations, you've come to the right place! If you spend a few hours with this book—then refer back to it next month and next year—you will gain a better understanding of your digital camera, and you will learn techniques that will help you consistently produce better nature photos.

This book is organized as a collection of two-page lessons. The lessons explain digital camera equipment, and then proceed to the fundamentals of exposure and composition, followed by techniques for photographing wildlife, landscapes, and close-ups. The lessons are illustrated with photos produced with both film and digital cameras; you can readily apply the techniques in this book to either medium. Look closely at the illustrations—including the exposure information—and ask yourself what you like or dislike, and how you could produce similar, or even better, results.

Ask yourself how you could produce similar, or even better, results.

Compared to film photography, digital imaging offers two huge advantages: (1) You can save a veritable fortune on film and processing, and (2) you have instant feedback. Digital cameras are able to instantly answer the photographer's question: "How am I doing?" Make optimum use of these advantages by taking a lot of images, then critically evaluating them.

The best nature photographers are not necessarily the folks with the most expensive equipment, or those who travel to celebrated photographic destina-

If you want to really see the world, get close to it! I lined up my camera perpendicular to the top of this Queen Anne's lace, to bring as many of the flowers into focus as possible. For more on close-up photography, read lessons 31 through 34. ($\frac{1}{125}$ second @ f/3.7, 95mm)

tions. During two decades of teaching photo workshops, I haven't noticed any correlation between the price tag of equipment that photographic students own and the quality of the photos they produce. Over the years, I've seen hundreds of publication-quality images taken by relative beginners with point & shoot cameras in their own backyards. And I've seen thousands of out-of-focus, poorly composed, or poorly exposed images taken with top-of-the-line photo equipment in national parks and wildlife refuges—in fact, I took many of those images myself!

In my experience, the really good nature photographers are people who have three characteristics: they enjoy being outdoors, they spend a lot of time photographing around the places where they live, and they continually learn from both their photographic mistakes and their photographic successes. You can be one of those people.

1. POINT & SHOOT AND PROSUMER CAMERAS

With a little basic information, you can determine which one of the three main types of digital cameras—point & shoot, prosumer, or digital SLR—best fits your photographic needs.

■ POINT & SHOOT DIGITAL CAMERAS

Point & shoot cameras are the smallest, least expensive, most elementary, and by far the most popular digital cameras. They are compact, automatic, and have built-in lenses. Point & shoot digital cameras are popular because they are easy to use and are inexpensive—generally $100 to 400. Point & shoot cameras automatically set focus, automatically set exposures, and they have built-in flash.

Point & shoots provide convenience, portability, and spontaneity for outdoor photography. Many digital point & shoots literally fit in your pocket. They are especially good for situations such as white-water rafting, skiing, backpacking, trail running, or rock climbing where bulkier or more expensive cameras may be impractical.

Many digital point & shoots literally fit in your pocket.

Point & shoots vary from simple, completely automatic models to more advanced models with the capability for manual control of exposures and focusing. Point & shoots usually have 3-, 4-, or 5-megapixel image sensors. Point & shoots typically have zoom lenses with a 3x to 5x range; in other words, the longest telephoto setting of the lens offers three to five times the magnification of the shortest wide-angle setting. Some models have 10x zooms for greater telephoto magnification.

Many point & shoots have a noticeable shutter lag. This is a delay—a large fraction of a second in some cases—between the moment you push the shutter release and the instant at which the image is actually recorded. Fortunately, digital camera design is continuously improving, and the newest point & shoot models have significantly less shutter lag.

■ PROSUMER DIGITAL CAMERAS

This increasingly popular name is a combination of "professional" and "consumer" that fittingly refers to cameras that have more professional features than the typical consumer point & shoot camera. These cameras are alterna-

tively known as "enthusiast," "advanced amateur," "advanced compact," or just plain "advanced" digital cameras—you get the idea!

There is no precise dividing line between point & shoot and prosumer digital cameras, but in general the prosumer category includes cameras that offer both automatic and manual control of exposure and focus, and a wide array of sophisticated features. Prosumer cameras usually have higher-resolution image sensors (5 megapixels or more), weigh more, are larger, and cost more (typically $350 to $800 at this writing) than most point and shoot digital cameras. They have zoom lenses ranging from 4x all the way up to "super-zooms" of 10x to 12x. Many prosumer cameras have the appearance of small or truncated single-lens-reflex (SLR) cameras.

Most prosumer models have an electronic viewfinder—in essence, a miniature version of the camera's LCD screen—which allows you to see the actual view through the camera's lens as you compose the image through the viewfinder. In contrast, most point & shoots have an optical viewfinder that is separate from the camera's lens. The optical viewfinder on a point & shoot is useful for composing images, but does not assist you with focusing to the degree that an electronic viewfinder does.

The sophistication of prosumer cameras, typically combined with a lower price tag than digital SLRs, make them the favorites of many intermediate-level and advanced photo enthusiasts.

Some "super-zoom" prosumer cameras have a 12x lens, which makes wild-life portraits much easier. ($\frac{1}{800}$ second @ f/5.6, 432mm)

2. DIGITAL SLR CAMERAS

Digital single-lens-reflex (SLR) cameras are the digital offshoots of traditional film SLRs. Digital SLRs have full automatic and manual control like prosumer cameras, high-resolution image sensors (generally 6 megapixels or more), and the advantage of interchangeable lenses. Just as with their film SLR cousins, one of the most attractive features of digital SLRs is that you can use any of dozens of different lenses—designed either by camera makers or by independent lens manufacturers—that range from extreme wide angle to long telephoto. Increasingly, special lenses are being specifically designed for optimal performance on digital SLRs.

Digital SLRs are the digital cameras of choice for most professional nature photographers. Owing to their film SLR heritage and their use by professionals, digital SLRs have a broader array of available accessories than other digital cameras. Digital SLRs also have highly accurate through-the-lens optical

viewfinders, and negligible shutter lag.

Digital SLRs—and some prosumer cameras—have the ability to capture images as larger, uncompressed RAW files, in addition to the compressed JPEG files that are the standard medium of most digital photography. If you want the absolute highest image quality for enlargement, and if you enjoy work-

LEFT AND FACING PAGE—The availability of many different lenses is one of the selling points of SLRs, both film and digital. The built-in lenses on most digital point & shoot and prosumer cameras do not extend to short enough focal lengths to provide a really wide-angle view such as the 28mm focal length used to record these two compositions of autumn foliage. ($^{1}/_{125}$ second @ f/4)

ing with image-processing software to enhance images and print your own photos, then these may be good reasons to choose a digital SLR.

So why don't we all rush out and buy a digital SLR? Digital SLR systems are larger, heavier, and—most notably—more expensive than most other digital cameras. At this writing, the least expensive digital SLR bodies are approximately $700, and lenses are an additional cost.

Some digital camera users who are considering the move up to a digital SLR may be concerned that, unlike other digital cameras, you cannot preview images on a digital SLR camera's LCD screen (the little monitor on the back of the camera). You must use the viewfinder—as with a film SLR—to compose images. On the positive side, a digital SLR viewfinder gives you an excellent, bright, through-the-lens view of scenes as you compose and focus them; what you see is what you get! And you can play back images on the LCD screen as on other digital cameras.

If you are already a film SLR user and have quite a few SLR lenses, then a digital SLR may be the right fit for you.

3. UNDERSTANDING LENSES

As noted earlier, a point & shoot or prosumer digital camera has a lens that is permanently built into the camera, whereas digital SLRs can accommodate many different lenses. A lens is identified principally by its focal length expressed in millimeters. In the 35mm film camera terminology that is routinely used to describe lenses, a lens with a focal length of approximately 50mm (about 2 inches) is considered a standard lens.

Any lens with a focal length significantly less than 50mm is a wide-angle lens, for example, a 24mm, 28mm, or 35mm lens. Wide-angle lenses show you a broader angle of view: the shorter the focal length of a lens, the wider the angle of view.

Any lens with a focal length significantly more than 50mm is a telephoto lens, for example, a 90mm, 135mm, or 300mm lens. Telephoto lenses magnify the subjects you view: the longer the focal length, the greater the magnification of the scene. Telephotos also compress space so that near and distant objects appear closer to one another.

The vast majority of photography today is done with zoom lenses. Unlike single-focal-length lenses, a zoom lens covers a range of focal lengths, and thus allows you to frame—that is, optically crop—a scene in a variety of different ways. For instance, a 28–70mm zoom lens extends from a moderate wide-angle focal length (28mm) to a short telephoto focal length (70mm). A 70–300mm lens extends from a short telephoto focal length (70mm) to a long telephoto focal length (300mm) suitable for photographing wildlife.

Digital camera technology has made the traditional understanding of lenses more confusing, because the image sensors on most digital cameras are far smaller than a frame of 35mm film. This has two significant consequences when you try to interpret the focal lengths of digital camera lenses:

1. For point & shoot and prosumer digital cameras, the focal lengths of lenses are far smaller than their 35mm film camera counterparts. For example, a 6–24mm zoom lens on a digital point & shoot may be equivalent to a 36–144mm zoom lens on a 35mm film camera. And to add to the confusion, there are numerous slightly different digital image sensor formats, so the conversion factor of digital focal length to 35mm-equivalent focal length varies from camera to camera. To avoid confusion, photo magazines, photo Web sites, and camera mak-

ers are increasingly identifying lenses on digital point & shoots and prosumer cameras by their 35mm equivalents. For ease of understanding, all focal length information given in the text and photo captions in this book refers to 35mm-equivalent focal lengths.

2. For most digital SLRs, which generally can use standard 35mm SLR camera lenses, the effective focal length of such a lens is typically 1.5 or 1.6 times as great as when used on a 35mm film camera. So, for example, on a given digital SLR, a 28–70mm zoom lens effectively may become a 42–115mm zoom, and a 70–300mm zoom lens effectively may become a 115–450mm zoom. This "multiplier effect" that makes focal lengths effectively at least 50 percent longer is terrific for wildlife photography, but a detriment for wide-angle landscape photogra-

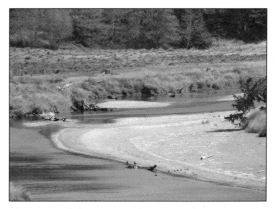

This series of three images from a single vantage point illustrates the versatility of the 12x super-zoom lens of a prosumer camera. Focal lengths of 36mm (top), 115mm (middle), and 432mm (bottom) show the difference between a wide-angle view, a short telephoto view, and a long telephoto view. ($\frac{1}{500}$ second @ f/4)

phy. Lens makers are responding to the wide-angle dilemma by designing more lenses specifically for use with digital SLRs.

13

4. DIGITAL CAMERA BUYING TIPS, PART 1

Selecting just the right digital camera is not getting any simpler! Some photo retailers stock over two hundred different digital camera models, and new models are introduced every month. The following guidelines will help you make an informed choice:

■ TYPE OF CAMERA

Consider which type of digital camera best fits your needs: point & shoot, prosumer, or digital SLR. Many amateur photographers find satisfaction with the compact size and ease of use of a typical point & shoot digital camera. More advanced users, especially those who like to creatively experiment, are prime candidates for prosumer cameras. Finally, the digital SLR is the choice for professional photographers and many serious photo hobbyists, particularly for people who already have a considerable investment in lenses and other accessories that are compatible with an SLR of a particular brand.

■ LCD SCREEN SIZE

Buy a camera with a comparatively large LCD screen. Most people compose photos using the LCD screen on the back of a digital camera. The size of this screen generally varies from 1.5 inches to 2.5 inches (diagonal measure). There are strong

A 5-megapixel camera can produce high-resolution photographs, which are suitable for printing sizable enlargements. ($1/40$ second @ f/2.8, 80mm)

advantages to buying a camera with at least a 2-inch screen; a larger LCD screen makes it far easier to compose images, to review the images you have just taken, and to work with the menus to adjust camera settings. Though the size difference between a 1.5-inch LCD and a 2-inch LCD may seem trivial, when you are adjusting settings on your camera's umpteen menus or composing a close-up image, this difference is quite significant! The good news is that after years of increasing miniaturization of digital cameras, the manufacturers are starting to make more camera models with LCDs that are 2 inches or larger.

A larger LCD screen makes it far easier to compose images.

In addition to the size of the LCD screen, consider its quality. Do you find it clear and bright with easy-to-read menus? Can the LCD brightness be adjusted to enhance viewing in various outdoor lighting conditions?

■ MEGAPIXELS

Consider the capacity of the image sensor. This is the main number—expressed in megapixels (that is, millions of picture elements)—used to identify digital cameras. It tells you how much information the digital camera is capable of recording in a digital image. More megapixels can mean sharper enlargements. If your main use of digital photography involves viewing photos on a computer, e-mailing photos, posting photos on Web sites, and/or printing snapshot-sized prints, then a 3-megapixel camera is likely to meet your needs. If you want to print a lot of enlargements of 8 x 10 inches or larger, then you may be best served by a camera of at least 5 megapixels. Numerous digital cameras—especially of the prosumer or digital SLR variety—are now available with sensors of 7 megapixels, 8 megapixels, or larger.

While an 8-megapixel camera records much more information in each image than a 5-megapixel camera, keep in mind that cameras with larger image sensors cost more, processing larger images is slower, and higher-resolution images take up more storage space. Unless you are producing a lot of poster-sized enlargements, you may not find major practical benefits of owning a camera with a sensor larger than 5 or 6 megapixels.

5. DIGITAL CAMERA BUYING TIPS, PART 2

■ **OPTICAL ZOOM**

Consider "optical zoom" specifications. If wildlife or sports photography is very important to you, consider super-zoom cameras with 10x or greater optical zoom ranges. Such a camera gives you the equivalent of at least a 350mm lens in a 35mm film camera system. This telephoto "reach" allows you to greatly magnify relatively distant objects such as wildlife. If wildlife photography is not a major interest, then you will probably find a more typical—and less expensive—3x or 4x zoom to your liking. If you photograph a lot of big landscapes, you may want to opt for the wide-angle view afforded by one of the handful of point & shoot or prosumer digital cameras on which the short end of the zoom range is a 35mm-equivalent focal length of less than 30mm.

■ **DIGITAL ZOOM—IGNORE!**

Ignore "digital zoom" specifications! Digital camera advertisements say things like "3x optical/4x digital zoom." Digital zoom capability might sound like a plus, but you are unlikely to *ever* make effective use of a camera's digital zoom. In essence, a digital zoom simply crops the image in-camera to give the illusion of greater magnification. The price is a loss of image quality when you enlarge the image as a print.

■ **ERGONOMICS**

Buy a camera that feels good in your hands. Go to your local camera store and put your hands on a digital camera before buying. Is the shape and size of the camera such that you can hold the camera steadily while viewing the LCD screen or looking through the viewfinder? So much emphasis has been placed on miniaturization in digital camera design that some cameras are awkward to use because of their tiny size. Unless you are James Bond or Austin Powers, you probably don't need a mini-camera that is the size of a credit card and weighs little more than a wet feather. Also consider whether the camera controls are comfortable for you. You may find that your fingertips are too large to easily manipulate the tiny controls on a very small camera.

■ **SPECIAL FEATURES**

While any name-brand digital camera should produce good images, the "feature set" on each camera is slightly different. For instance, some digital cam-

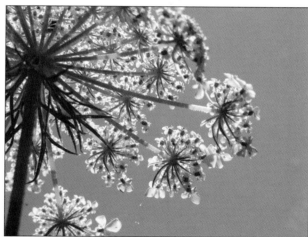

An LCD screen that swivels away from the camera makes low-angle close-up images far easier to compose without extreme physical contortions! The world is more interesting when you are looking skyward from underneath an umbel of Queen Anne's lace or from beneath the fronds of a spore-laden fern. ($^1/_{1000}$ second @ f/5.6 and $^1/_{250}$ second @ f/4; 105mm)

eras have dioptric adjustment of the viewfinder that lets you modify the focusing of the viewfinder to suit your eyes. Some digital cameras have LCD screens that tilt and swivel away from the camera either to reduce the glare on the LCD or to put the LCD in a position in which it is easier to view. And some models—especially super-zoom prosumer cameras—have a built-in image stabilization system that reduces the vibration of a handheld camera, letting you take steadier telephoto images. One or more features such as these may be major selling points in your decision to buy a particular model.

6. DIGITAL ESSENTIALS

■ MEMORY CARDS

Digital cameras use a variety of different reusable storage media, known as memory cards, to store images. When you purchase memory cards, make sure they are the right kind for your camera—SD, xD, CompactFlash, Memory Stick, and so forth—since different types of memory cards are not interchangeable.

Memory cards are surprisingly durable but not indestructible, and they are easily misplaced. Always take along a spare memory card on your photographic jaunts!

Most photographers find that cards of at least 128MB or 256MB are useful. The number of images you are able to record on a memory card depends on the size of the card, the size of your camera's image sensor, the resolution you select, and the image quality you choose. For instance, if you choose to make high-resolution, top-quality JPEG images with a 5-megapixel camera, you will likely be able to record about fifty images on a 128MB card or a hundred images on a 256MB card. Smaller memory cards fill up quite fast!

Unless you are sure that the only use of your images is for e-mailing and/or posting on the Web, set the camera to its highest resolution, also known as the "picture size" (for example, 2560 x 1920 pixels or "large" on many 5-megapixel cameras). Also set your camera to its best image quality (for example, "super fine" or "high-quality" JPEG on many digital cameras) to minimize compression of your files.

Take along a spare memory card on your photographic jaunts!

These suggested settings for resolution and image quality reduce the number of images you can record on a particular memory card until you download the images to your computer. But these settings will ensure that you record the greatest amount of information in each image file, and thus increase the chances that you can produce pleasing prints at larger sizes, such as 8 x 10 inches. If you print sizable enlargements—either at home or through a printing service—the larger file sizes of high-resolution, top-quality images pay off.

■ IMAGE-EDITING SOFTWARE

Most digital cameras and computer operating systems are packaged with basic image-editing software. This easy-to-use software meets the everyday needs of

The above left image was made with a 5-megapixel camera with the image quality at its highest setting and the picture size (a.k.a. resolution) set at 2560 x 1920 pixels, which produced a 2.4 MB file. The seemingly identical image to the right was made with the image quality at its lowest setting and the picture size set at 640 x 480 pixels, which produced a file less than one-tenth as large.

The difference between these two photos becomes noticeable with substantial enlargement. The photos above were produced by cropping a small portion from the lower-right corner of each the two upper photos. (¼ second @ f/7.3, 100 mm)

most amateur photographers who enjoy enhancing images for home printing, e-mailing or Web use. If you want to explore image processing beyond the capabilities of these programs, a plethora of image-processing software is available ranging from freeware to top-of-the-line $600 packages.

To try your hand at image editing, consider the under-$100 software first. One way to compare capabilities and ease of use is to take advantage of free thirty-day trials offered by industry leaders such as Adobe Photoshop Elements (www.adobe.com), Ulead PhotoImpact (www.ulead.com), and Corel Paint Shop Pro (www.corel.com).

7. FILTERS

Photographic filters are supplementary lens attachments that are screwed onto the front of a lens or mounted in a bracket attached to the lens. Filters can be used on virtually any digital SLR lens and are usually compatible with prosumer digitals, but many digital point & shoots are not designed for use with filters. Some camera makers sell "lens/filter adapters" that allow you to attach filters or accessory lenses to your digital point & shoot. Check your owner's manual or the manufacturer's Web site for more information.

Of the dozens of kinds of filters available, only a few are widely used for color nature photography. These popular filters are described below.

A polarizer can increase the overall color intensity in a scene.

■ **ULTRAVIOLET, HAZE, AND SKYLIGHT FILTERS**
Ultraviolet, haze, and skylight filters have very little effect on most photos. Many nature photographers always keep one of these filters on the front of their lens to avoid damage to the lens from accidental bumps. Use of these filters is a particularly good idea if you like to bushwhack, scramble over boulders, or photograph near waterfalls or in coastal areas with salt spray.

■ **POLARIZING FILTERS**
The polarizing filter or "polarizer" is a popular filter for outdoor photography. Polarizing filters have three major effects in outdoor photography:

1. A polarizer can remove reflections from shiny surfaces such as ponds, lakes, and wet leaves.
2. A polarizer can deepen the blue of the sky and increase the contrast between sky and clouds.
3. A polarizer can increase the overall color intensity in a scene.

When you put a polarizer on your lens, you can rotate the filter in its mount until you see the desired effect on your LCD screen or through your viewfinder. (If you have a point & shoot with an optical viewfinder, you must look at your LCD—not the viewfinder—to preview the effects of filters.) Thus you can selectively reduce reflections on water, deepen sky colors, or increase color

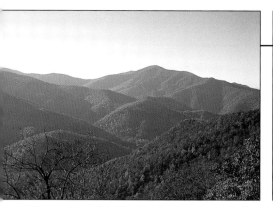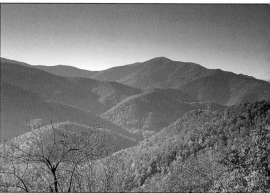

The eye is much better than image sensors or film at handling wide ranges of contrast. Compare the photo at left made without a filter, and the photo at right in which a graduated neutral density filter has darkened the sky to bring it into tonal balance with the land, thus restoring truer colors to both land and sky. ($\frac{1}{90}$ second and $\frac{1}{30}$ second at f/11, 40mm)

intensity. A polarizer has the greatest effect on the sky when the sun is at your side (at a right angle to the direction you are pointing your camera) and has minimal effect when the sun is directly in front of you or directly in back of you. The reflection-cutting effect of a polarizer is maximized when your camera's line of sight is at a 35-degree angle to the reflective surface, such as the surface of a lake.

Many photographers prefer the blue skies and intensified colors produced by a polarizer. Be judicious when you use this filter; it sometimes deepens sky colors so much and removes reflections so completely that a natural scene is transformed into a surreal, black-sky image.

Two types of polarizers are widely sold: "linear" and "circular." Use a circular polarizer with your digital camera; a linear polarizer may interfere with your camera's autofocus and exposure-metering systems.

■ GRADUATED NEUTRAL DENSITY FILTERS

Your eyes are far better than your camera's image sensor at perceiving high-contrast scenes. When you photograph a scene such as a sunrise that is split almost half-and-half between bright sky and darker-toned land, your image sensor is unable to reproduce the full range of contrast. Either the lighter areas end up with a washed-out appearance, or the darker areas end up as feature-less blocks of black. A graduated neutral density filter, which is half gray and half clear, can effectively darken the lighter parts of the scene, thus reducing the overall contrast in the scene to a reproducible level.

8. TRIPODS

A tripod is a vital accessory for nature photography. Professional nature photographers routinely use tripods because the probability of producing a sharply focused, well composed, accurately exposed photo is greatly enhanced when you have the camera on a tripod. You also have the capability of taking much longer exposures than when you hold the camera in your hands.

A basic tripod is surprisingly inexpensive (about $30) and lightweight (2 to 3 pounds). If you are in the market for a tripod, take your digital camera to your local camera store, and try out the tripods. Consider the following five factors:

1. Make sure the tripod is light enough to carry on your photo excursions. A tripod of more than five pounds is too heavy for most people to comfortably carry. Most tripod manufacturers now offer carbon fiber tripods that combine strength and stability with lighter weight; the drawback is generally a price of $250 and up.

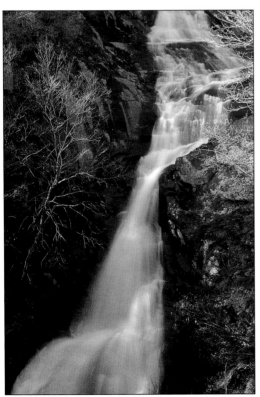

2. Make sure the tripod is heavy enough to support your camera in a stable fashion on uneven terrain in a stiff breeze. For digital SLRs, make sure the tripod supports your camera and its longest lens.

3. Check how low the tripod will allow you to get; this is very important for close-up photography of wild-flowers and small animals.

A tripod is a photographer's best friend! The stability provided by a tripod allows you to record exposures that could not be made with a handheld camera, for example, this silky, ½-second exposure of an Appalachian waterfall. (f/22)

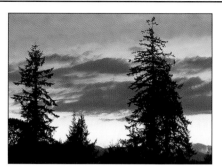

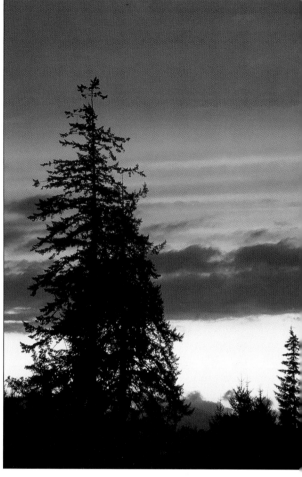

A tripod greatly expands your possibilities for low-light photography at dawn and dusk. I love to set up my camera on a tripod and work on the composition of a rapidly changing scene like these Douglas firs silhouetted against a fiery sky. (0.7 second and ½ second @ f/16, 200mm and 150mm)

4. Check how easy it is to adjust the tripod head—the part the camera attaches to—and to aim the camera in various directions at all angles. Consider a ball head or pistol-grip head that simplifies aiming the camera exactly as you desire. The pan-tilt head that is standard on most inexpensive tripods is considerably more awkward to use.

5. Check to see if the tripod head has a quick-release mount that allows you to quickly attach and remove your camera from the tripod.

When using a tripod, be sure to firmly attach the camera to the tripod and always make sure the tripod is stable before you take a photograph. To avoid shaking your tripod-mounted camera when you push the shutter release, use the camera's self-timer or the electronic remote switch that is available for some digital cameras.

9. BATTERIES, FLASH, AND CAMERA CARE

■ BATTERIES

Digital cameras are well known and much reviled for their ability to consume electricity as if there was no tomorrow. Always carry spare batteries, and be very kind to your battery charger!

As a digital camera user, you can do a few things to significantly extend battery power. Most notably, turn off the camera's LCD screen when you are not actively using the LCD to navigate menus or to preview or review images. Secondly, turn off the camera itself when you are not using it for extended periods. Many digital cameras have power-saving features that will automatically shut the camera off if you do not activate the controls for a specified amount of time, measured in minutes. You can save a lot of battery power by setting this feature for a small increment of time. And to save wear and tear on the planet and a lot of money in the long run, use rechargeable batteries.

Just as with car batteries, the performance of digital camera batteries declines significantly at low temperatures. In below-freezing temperatures, you may coax extra life out of your batteries by keeping the camera close to your body beneath a parka or sweater when you are not photographing. If your batteries appear to die when you are photographing on a cold day, you may be able to revive them. Simply remove the batteries from the camera and warm them for a few minutes in your hands or against your body, then put them back in the camera.

■ FLASH

Almost all digital cameras have built-in electronic flash. You can improve many of your nature photos through judicious use of it. In particular, "fill" flash is useful to augment available outdoor light and reduce harsh shadows for daytime nature photography of flowers and other close-up subjects.

Keep in mind that the built-in flash on many point & shoot digital cameras is only effective up to approximately 12 feet. Check your camera owner's manual to determine the effective working distance of your built-in flash, and to understand the various flash modes programmed into your camera.

If you have a digital prosumer camera or digital SLR, and you do a lot of flash photography, you may find it useful to purchase a separate flash unit that mounts on the hotshoe on top of the camera. Such a flash will give you greater flash range and more options for flash photography. Flashes have various

Sunny days at the beach are a great time for outdoor photography, but windblown sand and salt spray can spell trouble for photographic equipment. On windy days at the shore, keep your camera covered except when you are actively making photos. ($1/320$ second @ f/8, 125mm)

degrees of electronic compatibility with particular cameras; for convenience, shop for a "dedicated" flash that is made specifically to work with your digital camera.

■ CAMERA CARE

The rigors of outdoor photography can be tough on your camera. Following a few care guidelines will ensure that your photo equipment has a long and productive life. Keep your camera as dry as possible. When you photograph in rain or snow, keep your camera covered except when you are actually taking pictures. Thick plastic bags are handy for protecting your digital camera in the field. When you return from photo jaunts, promptly dry your camera, tripod, and accessories with a soft towel. Do not microwave your camera!!!

In coastal locations, avoid getting sand or saltwater in your camera. Tiny grains of sand can wreak havoc with moving parts, and salt spray can cause internal components to rust. Never leave your camera uncovered on a beach towel. In the field, in the car, and at home, always protect your camera from dust and extreme heat.

10. EXPOSURE MODES

The exposure modes offered by your digital camera are tools to help you work with the nearly infinite range of ambient lighting conditions in the outdoor world. Exposure is determined by the intensity and duration of light that reaches your camera's image sensor. The ideal camera allows you to set exposures manually, to use semi-automatic exposure settings, and to use totally automatic exposures. Most digital cameras give you all these options, though some of the most inexpensive point & shoot models do not offer the option of setting exposures completely manually.

Here's a quick rundown of common exposure modes. Please note that camera makers sometimes use different abbreviations or icons for these modes:

1. **Program mode ("P" setting or "Auto" on many cameras):** Your camera's microchip "brain" is programmed to automatically select an appropriate exposure based on your ISO setting and the amount of reflected light from your photo subjects that reaches your camera. Your camera chooses the proper amount of light to allow in to your image sensor to produce a good photo.

2. **Aperture-priority mode ("Av" or "A" on most cameras):** You set the aperture (f-stop), and then the camera instantaneously chooses an

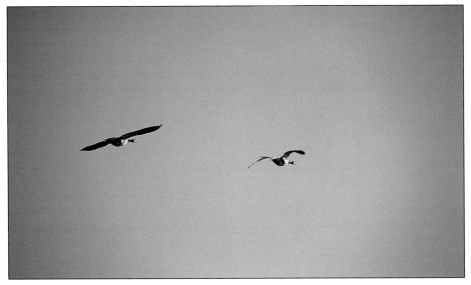

Geese in flight require a fast shutter speed to avoid blurring. This is a situation where a digital camera's "sports" scene mode is a good choice. ($^1/_{250}$ second @ f/5.6, 200mm)

Digital cameras have sophisticated light meters that frequently choose a suitable exposure while set on a totally automatic "program" mode. Subsequent lessons explore how you can take greater control of your camera's exposures settings to produce the desired results.

appropriate shutter speed. This is a popular mode among nature photographers because choice of aperture, as explained later, is often your top priority in setting the exposure for nature photos.

3. **Shutter-priority mode ("Tv" or "S" on most cameras):** You set the shutter speed, and then the camera instantaneously chooses an appropriate aperture. This mode is useful with photographic subjects that are in motion, since their appearance directly depends on how long you keep the shutter open.

4. **Manual mode ("M" on most cameras):** You set both the aperture and shutter speed, maximizing your control over each exposure.

Nearly all digital cameras also have other subject-specific "scene modes" that are programmed to automatically give you optimum exposure and focus in a particular situation. For instance, a "sports" scene mode (symbolized by a runner icon) preferentially chooses faster shutter speeds to freeze motion—ideal for photographing fast-moving wildlife. Other scene modes include landscape, sunset, snow, and close-up ("macro"). See your owner's manual for descriptions of your camera's exposure modes.

11. WHAT IS SHUTTER SPEED?

To manually control exposure and creatively fine-tune your photos, you need to understand shutter speed and aperture, and the important relationship between these two variables. Shutter speed refers to the amount of time your camera's shutter stays open—thus allowing light to reach the image sensor—when you take a picture. Cameras, both digital and film, use a standard series of shutter speeds measured in fractions of a second (diagram 1).

$\left. \begin{array}{l} \text{1/1000 second} \\ \text{1/500 second} \end{array} \right\}$ fast shutter speeds

$\left. \begin{array}{l} \text{1/250 second} \\ \text{1/125 second} \\ \text{1/60 second} \end{array} \right\}$ intermediate shutter speeds

$\left. \begin{array}{l} \text{1/30 second} \\ \text{1/15 second} \\ \text{1/8 second} \\ \text{1/4 second} \end{array} \right\}$ slow shutter speeds

$\left. \begin{array}{l} \text{1/2 second} \\ \text{1 second} \end{array} \right\}$ very slow shutter speeds

Diagram 1.

Each of these shutter speeds is twice as long as the one listed above it and one-half as long as the one listed below it. Changing the shutter speed by one "stop" means changing from one shutter speed to either the one listed above it or below it.

Some cameras allow you to use shutter speeds faster than 1/1000 second—such as 1/2000 second or even faster. Nearly all digital cameras allow you to take exposures of multiple seconds as well. Digital SLRs and some prosumer cameras give you the option of either setting the shutter speed to a value of multiple seconds, or setting the shutter speed to "B" and keeping the shutter open as long as you want by using an electronic remote switch.

Most digital cameras also allow you to use shutter speeds that are intermediate between the shutter speeds listed in this series; these in-between shutter speeds are usually at 1/3-stop intervals, for example, a 1/80-second shutter speed is 1/3 stop faster (shorter) than a 1/60-second shutter speed and 2/3 stop slower (longer) than a 1/125-second shutter speed.

With all these possible shutter speeds to choose from, how do you select the right one? See lesson 12!

FACING PAGE—Each photo is the product of some combination of shutter speed and aperture. If there is any motion in the scene you photograph, then your choice of shutter speed will determine whether and how that motion appears in the image. Here, a shutter speed of 1/60 second records the moving reflections of the autumn forest in rippling waters, and thus produces a soft, painterly effect. Appreciably shorter exposures would appear sharper; longer exposures would be even more blurred and abstract. (f/2.8, 155mm)

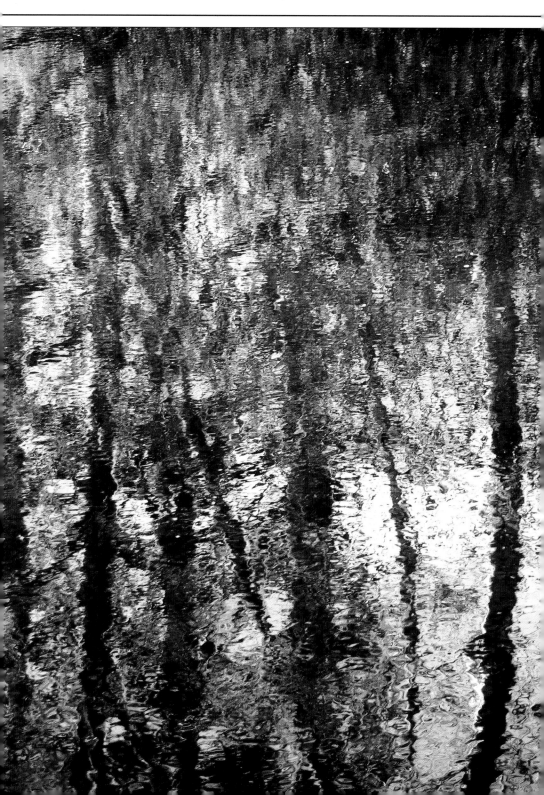

12. HOW TO CHOOSE SHUTTER SPEEDS

Your choice of shutter speed is critical when your photo subject is moving. If you use slow shutter speeds—$1/30$ or $1/15$ second, for example—to photograph moving animals or flowers blowing in the breeze, your photo subjects will usually be blurred. Such long exposures can produce some artistic images—especially when the blurring is pronounced—but most of the time nature photographers are trying to record sharply focused subjects. A fast shutter speed, $1/500$ second, for instance, will nearly always freeze the motion of a flower in the breeze or a moving animal, and thus can produce a sharp image.

When an animal's motion is slow or when the animal is far enough away to appear quite small in the image, a shutter speed of $1/125$ or $1/250$ second is often adequate. There are no hard-and-fast rules here; the best way to determine what shutter speed is necessary in a particular situation is to learn from the instant feedback your camera gives you.

Most people—even very calm people—cannot hold a camera perfectly still for more than a small fraction of a second. If you do not use a tripod, "camera shake" will often produce blurred images when you use slow shutter

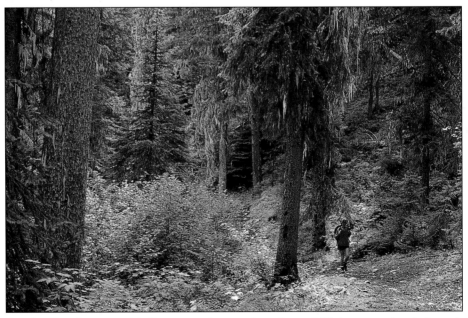

Any time there is movement in the scene and you want people or wildlife to appear sharply focused, keep in mind that slow shutter speeds will not freeze the motion. In general, when your subjects are not perfectly still, use a "triple-digit" shutter speed—that is, $1/100$ second or faster—if possible.

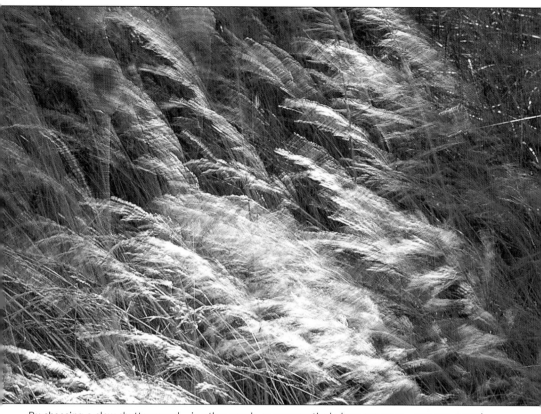

By choosing a slow shutter speed—in other words, a comparatively long exposure—you can record motion. This image of waving, windblown grasses was produced with a ⅓-second exposure. Photographically, one-third of a second is a long time! (f/32, 110mm)

speeds. A useful guideline with a handheld camera is to not use a shutter speed slower than the reciprocal of the 35mm-equivalent focal length of your lens. For example, when you use a camera with a 35mm-equivalent 35–105mm zoom lens (that is, a typical 3x optical zoom) set at 105mm—so that your photographic subject appears at its largest—you should try to avoid using shutter speeds longer than approximately ¹⁄₁₀₅ second. So ¹⁄₁₂₅ second or ¹⁄₂₅₀ second would likely produce a sharp image, but ¹⁄₃₀ second or ¹⁄₆₀ second would not. This is just a guideline; through experience you will learn what works for you.

If you have your camera securely mounted on a steady tripod, and your photographic subjects are not in motion, then your choice of aperture takes precedence over your choice of shutter speed.

13. WHAT IS APERTURE?

Aperture refers to the size (specifically, the diameter) of the lens opening through which light passes to reach your image sensor. The lenses on both digital and film cameras have a standard series of apertures expressed as f-stops (diagram 2).

On particular lenses, this series of f-stops may not extend so far or the series may extend further in either direction, for example, to f/2 or to f/32. On most digital SLR lenses, the smallest aperture is near f/22, but on most digital point & shoots and prosumer cameras, the smallest lens aperture is approximately f/8.

This seemingly odd series of apertures is set up so that each aperture allows in twice as much light as the one below it and one-half as much light as

The smaller the lens opening, the longer the shutter must remain open to record the image. In this instance, a tiny f/32 lens opening required a comparatively long 2-second shutter speed to produce a suitable exposure. The long exposure effectively smoothed the turbulence in the water between river rocks. (110mm)

the one listed above it. Changing the aperture by one "stop" means changing from one aperture to either the one listed above it or below it. Your lenses also may allow you to set apertures at third-stop intervals, for example, at f/6.5 and f/7.3, which both fall between the standard full stops of f/5.6 and f/8.

f/2.8 — largest aperture: lens is "wide open"

f/4
f/5.6
f/8 } intermediate apertures
f/11
f/16

f/22 — smallest aperture: lens is "stopped down"

Diagram 2.

The largest aperture of a particular lens is referred to as the "lens speed," and a lens is identified both by its focal length(s) and its lens speed. For example, a digital point & shoot may have a 35–140mm f/2.8–5.6 lens. This means that when the lens is set at 35mm, it has a maximum aperture of f/2.8; when set at 140mm, it has a maximum aperture of f/5.6.

The faster a lens is—that is, the greater its lens speed—the greater its light-gathering capacity. Thus, faster lenses can be used more effectively in lower light conditions. A lens with a maximum aperture of f/2.8 or less is considered quite fast. The value of fast telephoto lenses becomes evident when you photograph wildlife in low light!

Key point: Increments of aperture and increments of shutter speed are both measured in stops. When you change either the aperture or shutter speed by one stop, you either halve or double the light that will reach the image sensor. Because of this reciprocal relationship between changes in shutter speed and changes in aperture, in any given situation you have the choice of several different combinations of aperture and shutter speed to expose your image sensor to the correct amount of light. For example, if your camera's built-in exposure meter indicates that f/5.6 at $\frac{1}{125}$ second is a correct exposure, then f/8 at $\frac{1}{60}$ second and f/4 at $\frac{1}{250}$ second would also allow the same amount of light to reach the image sensor.

So how do you select which aperture to use? See lesson 14!

14. HOW TO CHOOSE APERTURES

As noted earlier, proper choice of shutter speed is critical when you photograph moving subjects and also when you handhold your camera. But if your photo subject is not moving and you have mounted your camera on a tripod, then selection of aperture takes priority over choice of shutter speed.

Aperture is important because it helps determine the "depth of field" in your photos. Depth of field refers to the range of distances, from near to far, that appears sharply focused in a photo. This zone of sharpness extends from some distance in front of the point on which your lens is focused to some distance behind the point on which your lens is focused. The depth of field in nature photos varies from fractions of an inch to many miles!

Key point: The smaller your lens aperture, the greater your depth of field. If you set your lens at the smallest apertures available, you will have more depth of field than at large apertures. When you adjust the aperture, you may

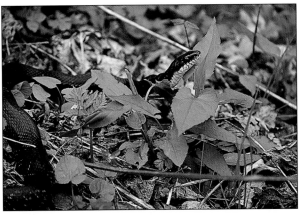

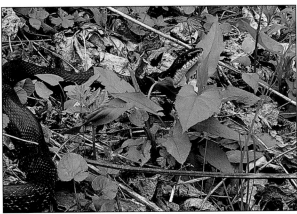

Aperture has a major influence on the appearance of a photo because a smaller aperture—that is, a higher f-stop number—causes more of the photo to appear in focus. The top photo was made at f/5.6, limiting depth of field, and thus emphasizing the snake's head. The bottom one was made at f/32, and thus has greater depth of field, bringing the whole scene into focus. Which one do you prefer? (1/90 second [top] and 1/5 second [bottom], 200mm)

find it useful to think of yourself as dialing in the preferred amount of depth of field. Apertures such as f/2.8 and f/4 give less depth of field, f/16 and f/22 give more. (Again, f/8 or thereabouts is likely the smallest aperture available on your digital point & shoot or prosumer camera.)

You can decide whether the visual effect is the way you want it.

Please note that depth of field also depends on the focal length of the lens—the longer the focal length, the less depth of field—and on the distance the lens is focused at—the greater the focusing distance (that is, the distance from the camera to the subject on which you have focused), the greater the depth of field.

There are a few ways to determine how much depth of field you have in a particular photographic situation:

1. Depth-of-field tables, which list the depth of field for a given focal length, aperture and focusing distance, are available in photo reference books as well as on many Internet photo sites. However, very few nature photographers use these tables, because the precise distances listed in the tables are difficult to correlate with what you see with your eyes as you photograph.

2. If you have a point & shoot or prosumer digital camera, when you depress the shutter release halfway, the camera's autofocus system is activated. When the camera focuses, the scene appears on your LCD screen with the actual amount of depth of field that will be in the recorded image (as long as you keep the shutter release depressed). It's magic . . . well, at least it seems like magic! If your camera has an electronic viewfinder, as many prosumer cameras do, you will also conveniently see this LCD image through the viewfinder.

3. Similarly, a depth-of-field preview feature built into nearly all digital SLRs lets you see the actual depth of field through your viewfinder. When you activate the depth-of-field preview feature, you are manually "stopping down" the lens diaphragm to the aperture at which the lens is set. Then you see the depth of field as it will appear in your photo, and you can decide whether the visual effect is really the way you want it.

15. DIFFICULT EXPOSURE SITUATIONS

When your camera's built-in exposure meter judges how to expose a particular scene, it is measuring the amount of light reflected toward the camera from various parts of the scene. Exposure meters are calibrated to choose an exposure that will reproduce an overall medium-gray tone in the image; this medium gray is a middle tone in between white and black. So your meter works fine when the scene you photograph is largely made up of middle tones, and your camera will often automatically select a suitable exposure. This is true in many outdoor scenes, for example, if the composition is dominated by evenly lit green foliage.

You sometimes encounter tricky situations where your exposure meter does not automatically choose an optimal exposure. When the image sensor is exposed to too much light while recording an image, the photo comes out too light and is an overexposure; colors appear less vivid, and the image may even appear "washed out." When the image sensor is not exposed to enough light, the photo comes out too dark and is an underexposure.

A challenging situation in nature photography is a scene dominated by shades that are considerably lighter than a medium-gray tone, for example, a white sand beach, a snowy landscape, or sun reflected off the surface of water. Your camera's exposure meter expects the world to be a medium-gray tone on average, and the meter suggests exposures that will produce middle-toned photos. Consequently, photographs of white or very bright subjects often come out grayish, not white, because they are underexposed.

When you encounter these scenes that are much lighter than medium gray, think of the phrase, "Add light to light!" If your camera's suggested exposure comes out too dark, then purposely overexpose ("add light") compared to your exposure meter reading. Use your digital camera's exposure compensation control to set your camera to overexpose. You will learn how much to overexpose—one-third stop? two-thirds stop? one stop?—in a given situation through experimentation. Any time you use exposure compensation, be sure to turn off this feature as soon as you have taken the picture. Otherwise you may end up with a slew of accidentally overexposed images!

In difficult exposure situations, you can learn a great deal when you take two or three exposures of the same scene with slightly different exposure settings. This technique of making an exposure at the metered setting, then making additional exposures at other settings varying from one another by partial

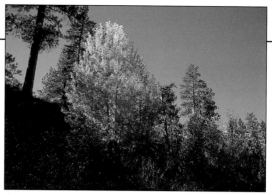

or full stops is called "bracket-ing" exposures. You can set many digital cameras to do this automatically. Digital imaging is at its best in such situations, since you can quickly review your images—the sooner, the better—and not only produce an optimal photo but also add what you learned from the experience to your photographic knowledge base.

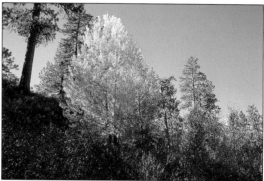

Most digital cameras give you the option of using a built-in spot meter. This is an exposure meter that only eval-uates a small spot (or zone) in the center of the scene in your viewfinder. In high-contrast exposure situations, one strat-egy to get a correct exposure is to use your camera's spot meter to read the light reflect-ed from the most important subject in your photo. As a general rule, lean toward metering lighter parts. Many beginning digital photogra-phers have problems because the lightest portions of con-trasty scenes may appear

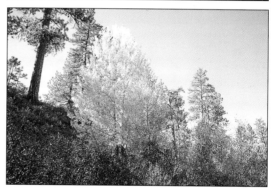

When you are unsure of correct exposure, then bracket your exposures by making two or three images with slightly different shutter speeds or f-stops. The top image is one stop underexposed, the second is a metered expo-sure, and the third is one stop overexposed. In this par-ticular case, the metered exposure accurately repro-duced the colors of the fall foliage and sky. ($\frac{1}{350}$ second, $\frac{1}{180}$ second, and $\frac{1}{90}$ second @ f/5.6; 28mm)

"blown out." By selectively spot metering off of a lighter part of the scene, this problem is reduced. As always with digital photography, let the feedback on your camera's LCD screen—or later on your PC monitor—be your guide.

16. MAKE THE BEST OF NATURAL LIGHT

he vast majority of nature photography relies solely on ambient light. One of the biggest challenges is to learn to work successfully with a wide array of lighting conditions. You will learn through experience to appreciate and creatively work with the direction, quality, strength, and color of light.

As for the direction of light, when the sun is at your back and your subjects are lit from the front, color and detail stand out, but the overall scene often appears rather flat. In contrast, sidelighting is wonderful for bringing out textures and a sense of depth in photos.

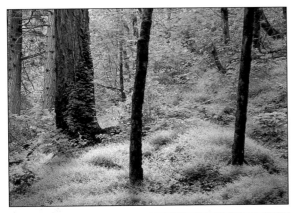

One of the joys of photographing nature is to become an avid observer of ambient light. Once you have composed a scene with your camera mounted on a tripod, you can sit back and record interesting—and sometimes dramatic—changes in lighting. (¹/₆ and ¹/₁₅ second @ f/6.7, 200mm)

Backlighting is terrific for dramatic images. When you photograph strongly backlit subjects, you will typically end up with silhouetted subjects unless you purposely overexpose compared to your meter reading (or use flash to light up nearby subjects). In strongly backlit situations, you may find that setting your exposure compensation control to +1 stop or more will brighten your subjects adequately. However, you may prefer silhouettes in backlit situations; try it both ways and see what looks best!

Direct sunlight can be harsh and contrasty—especially in summer—whereas cloudy days reduce contrast. The soft light of an overcast day is a favorite of many professional photographers. The colors of flowers and foliage may also appear richer under the diffused light of an overcast sky.

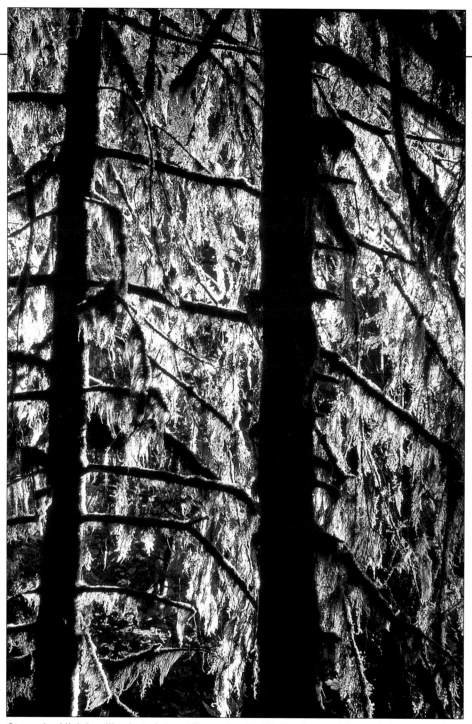

Strong backlighting illuminated the stillness of a Pacific Northwest old-growth forest. The low-angle sunlight of early mornings and late afternoons is ideal for this look. (2 seconds @ f/32, 180mm)

17. ISO

ISO is the standard measure of the light-sensitivity of a digital camera's image sensor. This terminology is a carryover from the traditional use of "ISO" (short for International Organization for Standardization) as the standard measure of the light-sensitivity of photographic film. In the context of digital imaging, you might think of ISO as "Image Sensor Optimization" to help you remember its meaning.

The range of ISO settings for most digital point & shoot and prosumer cameras extends from somewhere between 50 and 100 on the low end to 400 on the high end. For digital SLRs, the ISO range typically extends from approximately 100 to 1600.

Digital cameras automatically choose an ISO, or you can manually set the camera to an ISO of your choice. Doubling the ISO setting makes the image sensor twice as sensitive to light. Though lower ISO settings offer less sensitivity to light, they offer the distinct advantage of producing less "noise" in your digital images. Noise could be likened to the graininess of some high-

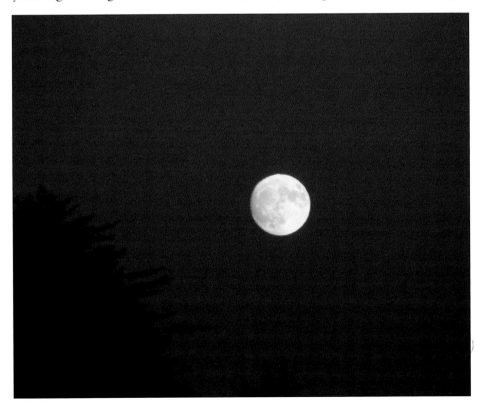

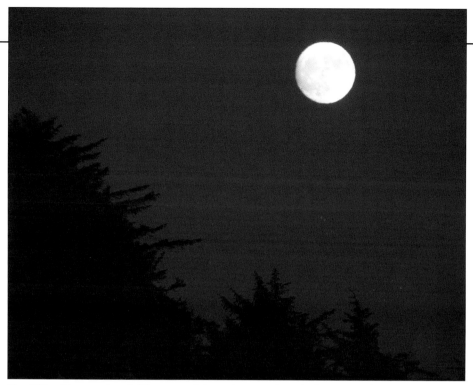

Two ISO settings produced different renditions of a moonrise. The first one (facing page) was made at ISO 400; the second (above) was made minutes later at ISO 80. In both cases, I intentionally underexposed 2 stops compared to the metered exposure to avoid "blowing out" the already-bright moon. ($^1/_{400}$ and $^1/_{80}$ second @ f/2.8, 432mm)

speed photographic films. At higher ISO settings, particularly 400 or higher, many digital cameras produce images that have a noticeably grainy look—particularly in the darker areas of images—because of tiny random spots that appear in the image. Noise may become far more noticeable when you make very long exposures of multiple seconds or more.

There is nothing inherently bad about grainy images; in fact, graininess can be aesthetically desirable in some photos. But grainy images stand out because we are accustomed to seeing very sharp, grain-free nature photos. Keep in mind that graininess will appear much more noticeable in enlargements. Unless you purposely want "noisy" images, use low ISOs—100 or less—when possible.

One situation in which you usually do not have the luxury of using a low ISO is when you photograph wildlife in the low light of dawn or dusk. You may have no choice but to use your highest ISO setting (400 on many cameras) to obtain fast enough shutter speeds to "freeze" the motion of animals.

18. WHITE BALANCE

White balance refers to the calibration of a digital camera's image sensor to produce true-to-life and/or pleasing colors in an image. The basic concept is that by calibrating your camera in particular lighting conditions so that white truly appears white, the overall color cast of an image will appear true to nature. Digital cameras automatically adjust white balance by default, though on all but the most basic cameras you also have the ability to manually control the white balance at any time.

When should you rely on the camera's automatic white-balance setting? Ask yourself two questions: Does the color balance in the image you see in your LCD screen (either before or after you make the photo) look like what you see in the actual scene you are photographing? Does the color balance in your digital image look as you wish? If the answer to these questions is "no," then consider changing your white-balance setting.

In addition to the default "auto" setting, the white-balance settings on digital cameras usually include daylight (also known as "sun"), cloudy (also known as "overcast" or "shade"), flash, incandescent light, and possibly a few others. White-balance settings do make a difference; for example, the cloudy setting will give a noticeably warmer cast to many of your photos than the daylight setting. The incandescent light setting—actually intended for indoor use—will create cooler, bluer outdoor images.

Many digital cameras also let you create a custom white-balance setting, by calibrating the white balance in a given lighting situation. Follow the instructions in your owner's manual if you want to try this for yourself.

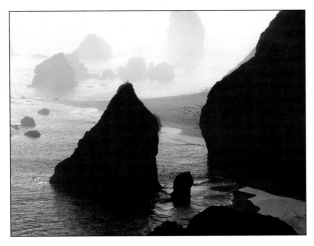

LEFT AND FACING PAGE—These three images, taken with diffuse sunlight shining through a coastal fog, show how the white-balance setting can affect photos. The left image was set for daylight, the top image (facing page) was set for cloudy to warm it up, and the lower image (facing page) was set for incandescent lighting to give it a cooler cast. ($\frac{1}{1000}$ second @ f/7.3; 185mm)

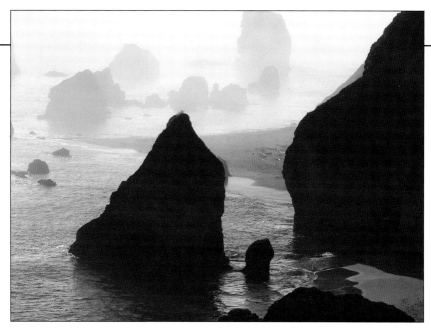

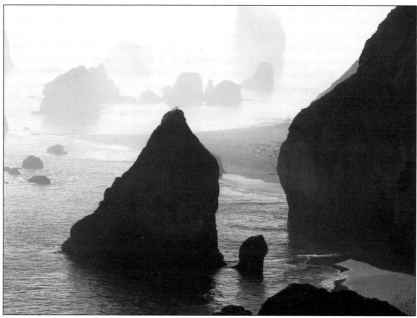

Selection of white balance is largely a matter of personal preference. A good approach is to experiment with both your camera's automatic and manual settings in various lighting conditions. Then review the results both on your LCD screen and later on your PC monitor. Most image-editing software also gives you the ability to alter the color cast after the fact.

19. EXPOSURE HISTOGRAMS

Many prosumer digital cameras and some high-end point & shoots provide "live" exposure histograms on their LCD screens and electronic viewfinders. You can view this live histogram as you preview the image before pressing the shutter release. The histogram can also be displayed when you review the image after you have taken the photograph.

Digital SLRs offer you a histogram when you review the image on the LCD screen, but not as a live display prior to the exposure. Many image-editing programs also provide histograms to use as you fine-tune your images after transfer to your PC.

A digital camera's exposure histogram is a small, rectangular graph showing the frequency distribution of tones in the image, ranging from black (far-left side of histogram) through middle tones (center) to white (far-right side of histogram). The more prevalent a particular tone is in an image, the greater the height of the graph at that particular point. Histograms characteristically have one or more peaks, sort of like a jagged mountain range seen in profile.

There is no perfect histogram for all nature photos any more than there is a perfect subject for all photos! The shape of the histogram will vary with subject, lighting, contrast, exposure, ISO setting, and the mood you want to convey in the image.

Suffice it to say that you may benefit from (1) previewing a live histogram as you compose an image and select exposure settings, and (2) reviewing a histogram of the image you just made, to see if you want to photograph the same scene again differently. By changing shutter speed, aperture, ISO setting, or

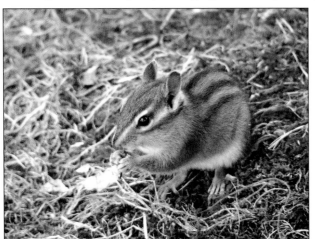

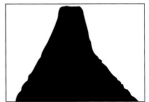

The histogram for this chipmunk photo shows a wide tonal range with a single peak in the middle tones between black (left) and white (right). (¹⁄₆₀ second @ f/2.8, 432mm)

The histogram for this image illustrates a bimodal distribution of tones. The peak on the left side of the histogram represents the darkest tones in the image, that is, the darkest parts of the teasel. The high peak toward the right is the signature of the sky, lighter than a medium-gray tone. I purposely overexposed the image by 1 stop compared to the meter reading to bring out more color and texture in the teasel. ($^1/_{250}$ second @ f/5.6, 432mm)

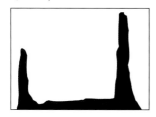

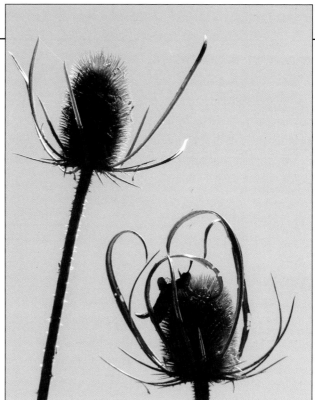

composition, or by waiting for the earth to rotate a bit, you will alter the histogram, and thus you will alter the resulting image.

Watch out for situations in which the histogram is concentrated—"clipped"—at either the extreme left (black) or extreme right (white) ends of the graph. Too much black could mean underexposure and loss of detail in the shadows; too much white could mean overexposure and loss of detail in the highlights. An image for which the "mountains" (higher chunks) of the histogram extend almost to the far left and/or far right of the graph may be preferable. Many good outdoor photos contain a wide range of tones extending from nearly black to nearly white.

A creative approach to exploring the tonal range of your digital images in the field is to occasionally set your camera to its black & white recording mode so that you can preview images (on a point & shoot or prosumer camera) or actually make black & white photos to compare with your color ones. And even if you do not photograph in black & white, you can use most image-editing software to duplicate your photos and convert them to black & white for comparison.

20. COMPOSITION, PART 1

■ CLARIFY YOUR MESSAGE

Photos communicate. Good nature photos communicate well! Photographic composition refers to the arrangement of visual elements in a photo. As a photographer, you use lines, shapes, colors, tones, patterns, textures, balance, symmetry, depth, perspective, scale, and lighting to bring your images to life. A practical approach to nature photo composition is to look at your LCD screen or through your viewfinder and ask yourself two questions.

1. What is my message?
2. What is the best way to communicate this message?

Nature photos are successful when the message is clear. When the photographer's message is garbled, ambiguous, weak, or obscured by distracting visual elements in the composition, the photo is not a keeper. Nature photos that convey a powerful message will compel the viewer to take a second look to soak in the beauty and meaning of the image.

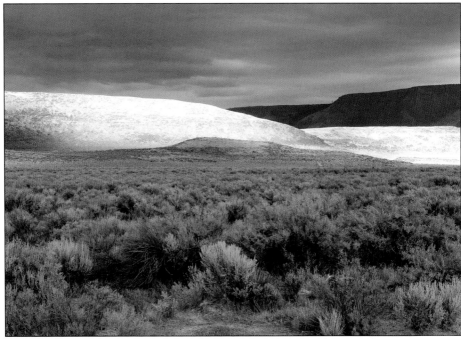

Consider how the elements of color, texture, contrast, shape, perspective, and scale each play a role in creating a satisfying landscape image. ($^{1}/_{40}$ second @ f/8, 65mm)

Simplify! Once you settle on a photo subject and roughly line it up in your viewfinder or on your LCD screen, move your camera left, right, up, and down to see if you can improve the composition. Consider the role that the old snag plays in giving a sense of depth to this big Rocky Mountain landscape.

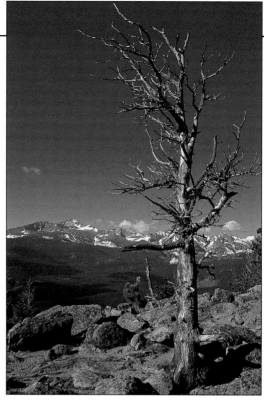

■ KEEP IT SIMPLE

The single best watchword to keep in mind as you compose photos is simplicity. Notably, some professional nature photographers actually take a "subtractive" approach to composition rather than an "additive" approach. Rather than dwelling on what they can add to the composition, they focus on what can be removed to strengthen the composition.

In many cases, a poor composition can be turned into a good composition by fine-tuning through the viewfinder or on the LCD screen; just move the camera slightly left, right, up, or down with simplicity as a goal. Compositions suffer when your message is diluted by unwanted visual distractions. Avoid visual clutter, and your compositions will sing!

■ BE PATIENT

Good photo composition takes time; great photo composition takes even more time. Nature photos composed in five seconds or less usually bear little resemblance to those composed in five minutes or more. There are occasions in wildlife photography when you must rapidly point and shoot or else you will miss the opportunity altogether, but many nature photo subjects change very slowly. When you slow down to meticulously compose photos, the rewards may include a relaxing meditative experience along with vast improvement in your photos. How much better would your nature photos be if you spent at least five minutes composing each one?

21. COMPOSITION, PART 2

■ FILL THE FRAME

Just as a landscape painter would not totally ignore a portion of the canvas, you should not ignore any portion of the scene that you frame. Make the best use of the entire "canvas" of each photo. When you look through your viewfinder or at your LCD screen, think of it as a rectangular picture frame. As you compose, make use of all the available space. Fill the frame!

You can significantly strengthen many of your compositions by zooming in as much as your lenses allow or, if possible, getting closer to your subject. Photographic compositions are weakened when important subject matter is too small to see.

■ CONSIDER VERTICALS

Most photographers have a pronounced tendency to take far more horizontal photos than verticals. But many landscapes have strong vertical elements such as trees, mountains, and waterfalls. Also, depending on your perspective, even horizontal landscape features can appear vertical. If you are standing high on a bridge and looking up or down a relatively straight river, the river will appear as a vertical element in your photo. And in close-up photography, even the stem of a wildflower or a blade of grass can be a strong vertical element.

Consider whether a vertical or a horizontal composition will be most attractive in each situation. You can enliven your nature photography if you

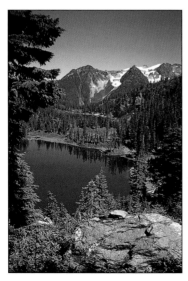

Vertical or horizontal? In every photographic situation, you face the choice between a vertical and a horizontal composition. Which one of these North Cascade landscape images do you prefer? ($^1/_{350}$ second and $^1/_{250}$ second @ f/4, 35mm and 28mm)

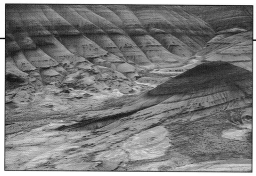

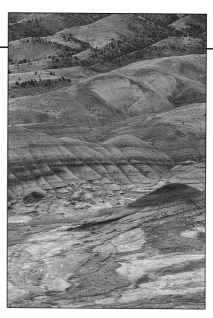

A zoom lens makes it possible to frame a scene many different ways; it's up to the photographer to develop a composition that works. Note the role that lines play in these photos. The horizontal image of Oregon's Painted Hills was made at a focal length of 200mm; the vertical image includes a broader view at 110mm. (1/$_{125}$ second @ f/8)

consciously take more verticals! See lessons 2, 8, 25, 26, and 30 for more examples of scenes photographed in both horizontal and vertical formats.

■ FIND LINES

You see lines almost everywhere you point your camera. How can you use these lines to enhance your photos? Three elements to look for in your photo compositions are diagonal lines, leading lines, and curved lines. Judicious placement of these lines can create memorable images.

Horizontal and vertical lines in photos often frame the scene or create visual boundaries within the image. Horizontal and vertical lines typically have a static appearance in nature photos, whereas diagonal lines frequently are where the action is. Diagonals are dynamic!

One type of diagonal line is known as a "leading line." A leading line may extend from the proximity of any of the four corners of a photo toward the middle of the image, or toward a significant feature in the image. You can find many leading lines in the landscape such as riverbanks, borders between field and forest, and fallen trees. A leading line often enhances a photo because it leads the viewer's eye into the picture; it visually links the foreground and background, creating continuity and an added element of depth.

Curved lines add aesthetic appeal to nature photos. In particular, S-curves are beautiful to the eye. S-curves include winding rivers, curled tree branches, sinuous vines, swirling clouds, and slithering snakes.

22. COMPOSITION, PART 3

■ PLACE SUBJECTS OFF-CENTER

Many photographers routinely compose photos with the main subject in the middle of the image. This approach characteristically produces images that look rather static as if they were studio portraits. You can often produce a more interesting image by placing the subject somewhere other than the center of the image. An easy way to keep this in mind is to use the "rule of thirds."

Imagine the scene on your LCD screen (or in your viewfinder) is divided into thirds both horizontally and vertically. To visualize this, pretend that a tic-tac-toe grid has been superimposed on the scene. (Some digital cameras even have LCD screens that display such a grid pattern.) Now compose the image so that the main subject of the photo is located approximately at one of the intersections of these imaginary "thirds" lines.

For instance, if a deer is the main subject of your photo, you might compose the image so that the deer is one-third of the way up from the bottom of the image and one-third of the way across from the left side of the image. You may also want to place prominent horizontal or vertical lines—such as the

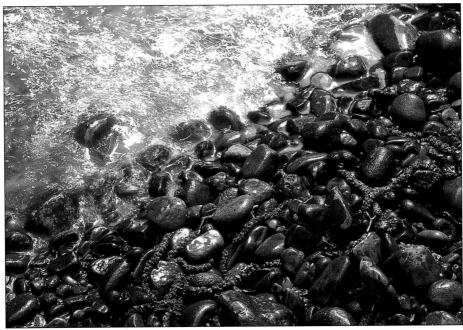

With your camera mounted on a tripod, you are likely to slow down and thus compose your images more deliberately. And, yes, the tripod holds the camera steady for longer exposures such as this ¼-second exposure of sunlight sparkling at the pebbled edge of an Oregon stream. (f/32, 200mm)

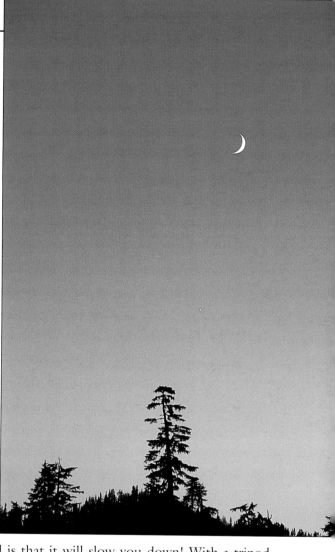

The rule of thirds is a simple guideline to encourage you to position important photographic subjects, such as the crescent moon in this image, away from the center of the composition to heighten visual appeal. (1 second @ f/9.5, 135mm)

horizon or a large tree trunk—approximately one-third of the way from one of the four edges of the image. The objective of this guideline is to diversify your compositions by consciously positioning your photo subjects away from the center.

■ TRY A TRIPOD

If you truly want to produce well-composed photos, use a tripod. A tripod is to nature photography what an easel is to landscape painting. A tripod is regarded by most nature photo pros as a necessity. Why? Surprisingly, the greatest benefit of a tripod is that it will slow you down! With a tripod, you will spend more time as you set up for each exposure, and you will compose more carefully.

As a beneficial side effect, when you use a tripod and move more slowly, your eyes and other senses will open up to your surroundings, and you will literally see more interesting photo subjects. Time and again, nature will seemingly come to life around you as your awareness increases. The fact that a tripod also gives you the practical advantage of holding the camera steady during long exposures—a second, a minute, or even an hour for a night sky exposure—is simply icing on the photographic cake!

23. FOCUS, PART 1

■ AUTOFOCUSING

Digital cameras have sophisticated autofocus (AF) systems. You can produce better nature photos by learning to make the full use of your camera's autofocus capabilities.

Check your camera owner's manual to learn where your camera autofocuses, and how to change the focusing mode. Most digital cameras give you the option of focusing either in the center of the image (called "center," "1-point," "single," or "spot" focusing), or on several areas or zones across or throughout the image (sometimes called "multi-area" focusing). Learn how to interpret your camera's LCD screen or viewfinder to determine where your camera is focusing; many cameras display the focusing mode on the LCD. For example, some cameras show a set of brackets ([]) in the center of the LCD when the camera is in a spot AF mode.

Learn to make the full use of your camera's autofocus capabilities.

Your digital camera actually focuses when you push down the shutter release halfway. Nearly all digital cameras have a focus-confirmation signal to show they have successfully focused, for instance, a steady green light. (Depending on the type of camera, this signal may appear on the LCD, in or next to the viewfinder, or in multiple places.) If you activate the autofocus by pushing down the shutter release halfway but do not receive your focus-confirmation signal, you are probably trying to get your camera to do something it cannot do (see lesson 24).

Assuming your camera autofocuses on a single central point or zone, be sure to put the main subject of your photo—or another object at the same distance from you as the main subject—at the center of the image when you activate the autofocus so that your subject will appear in focus.

■ PRE-FOCUSING

But what about all the situations where you want to focus on a subject that you do not want in the center of the image? Fortunately, nearly all digital cameras have a pre-focusing, or "focus-lock," capability that allows you to autofocus on your subject and then recompose. When you push the shutter release down approximately halfway (not so far down as to take a picture!), the camera autofocuses and remains focused at the same distance until you take

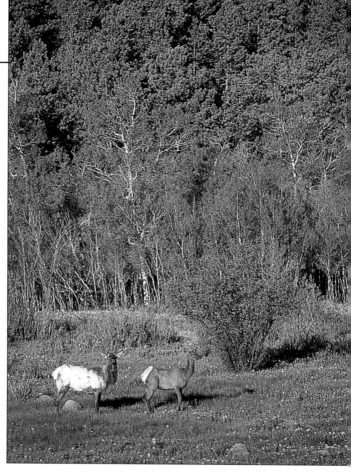

your finger off the shutter release.

To pre-focus, (1) center your subject in your viewfinder or LCD screen, (2) push the shutter release down halfway and check the focus-confirmation light, then (3) while still holding the shutter release halfway down, re-compose your photograph for the best composition, and (4) take the photo. This pre-focusing technique is easy once you do it a few times, and it can improve the majority of your photos because it frees you to create interesting compositions with the subject off-center, while ensuring that the subject is still in sharp focus.

If you are attempting to pre-focus as described above, make sure your camera is not in a "continuous AF" (also called "servo AF") mode. In continuous AF mode, the camera will continuously refocus as long as you are holding the shutter release halfway down, until you actually take the exposure. Thus, pre-focusing would be impossible. Continuous AF is very useful when photographing rapidly moving wildlife, but not when photographing landscapes or stationary subjects.

Many digital cameras—check your owner's manual—also lock the exposure setting when the shutter release is pushed down halfway. If this is true for your camera, each time that you pre-focus, you are also setting the exposure, unless you have already set a different exposure in the manual exposure mode.

24. FOCUS, PART 2

■ MANUALLY FOCUSING

Digital SLRs, prosumer, and high-end point & shoot cameras offer the option of manually focusing. In some cases, your autofocus system gets confused about your photographic intentions and does not know where to focus when it does not "see" any detail (lines, textures, shapes, patterns) in the center of the viewfinder. This may happen when you photograph a relatively featureless sky. Or if you photograph a landscape through a window, your camera may mistakenly autofocus on reflections in the window rather than on the scene outside. In such cases, manually focusing the lens is preferable.

When you manually focus, consider what is the most important point in the scene to get absolutely sharp. Then take your time and carefully focus.

If your digital camera has an electronic viewfinder, as many digital prosumer cameras do, you will probably find the viewfinder more useful than your LCD screen to judge whether a subject is in focus. But if you are using a digital point & shoot with an optical viewfinder, the viewfinder will be of no help in manually focusing—because the scene will appear the same in the viewfinder whether or not you have correctly focused—and the LCD screen is your best bet to evaluate focus.

■ GETTING FEEDBACK

Whether you autofocus or manually focus, take time for playback to review your important images in the field, and make sure the focus is okay before you move on. If your camera has the capability to enlarge your images to 4x or more on the LCD screen, this is very useful to judge image sharpness. Moving out of direct sunlight—or shading your camera with your body—will help you clearly see the LCD screen. If your images are out of focus, try to determine why, so that future images will be better. Consider the following possibilities:

1. What AF mode do you have your camera set on? Is your camera evaluating focus based on the entire image when you would really like it to be focusing solely on a subject at the center of the image? Or is your camera focusing solely on the center of the image when you would really like it to be taking other parts of the image into account?
2. Do you have the camera set on a scene mode that makes it unlikely or impossible to focus on your subject? For example, if your camera is set

Accurate focusing is essential when you are near the subject and depth of field is extremely limited. Here I chose to manually focus on the cattail spike; a 200mm focal length and an aperture of f/5.6 ensured that the rest of the image would be beyond the depth of field, and would not divert the viewer's attention. ($\frac{1}{180}$ @ f/5.6, 200mm)

on macro (flower icon), it may not be able to focus on a distant horizon. And if your camera is set on landscape (mountains icon), it may not be able to focus on a subject only 10 feet away from you.

3. Are you pushing the shutter release all the way down without a slight pause for your camera to focus? With some digital cameras, pausing very briefly after you have partially depressed the shutter release will increase the likelihood of sharply focused images by giving the camera sufficient time to focus prior to recording the image.

4. *Handheld camera:* Are your shutter speeds so slow that you are shaking the camera during the exposures? Check your shutter speeds as you shoot—consult your owner's manual to see how to display the shutter speed on your LCD prior to shooting—or later on your PC (image-editing software often allows you to display the exposure information for each image you download from your camera) to see if you are using fast enough shutter speeds. Refer back to lesson 12 for a guideline on shutter speed selection for handheld photography. If your equipment has a built-in image stabilization system, activate it when you handhold the camera for exposures lasting longer than triple-digit fractions of a second—for example, $\frac{1}{60}$, $\frac{1}{30}$, or $\frac{1}{15}$ second.

5. *Tripod-mounted camera:* Is your camera mounted loosely on the tripod, or is the tripod itself unstable, so that the camera moves when you press the shutter release? Use of the camera's self-timer—with a 2- to 10-second delay—greatly increases the probability that the camera is stationary at the moment the image is recorded.

25. LANDSCAPE PHOTOGRAPHY, PART 1

■ **PICK THE RIGHT FOCAL LENGTH**

Many different focal lengths are suitable for landscape photography. Wide-angle focal lengths, particularly in the 24mm to 35mm range, are frequently the choice for photographing big landscapes. Short to moderate telephoto focal lengths, especially focal lengths from 70mm to 135mm, are useful for landscapes that are not so broad, or for taking portraits of landscape features such as a grove of trees or a waterfall. And longer telephoto focal lengths of 200mm or even 300mm give you additional reach to single out and magnify more distant landscape features, for instance, a lone tree on a hilltop.

The notable drawback of digital photo equipment in landscape photography is that the built-in zoom lenses on most digital cameras do not offer very wide-angle capabilities. Characteristically, the shortest focal length on a digital point & shoot or prosumer camera is approximately 35mm. If you really enjoy wide-angle landscape photography, consider adding a wide-angle converter lens that is designed to fit your camera. Such a lens, which often attaches to

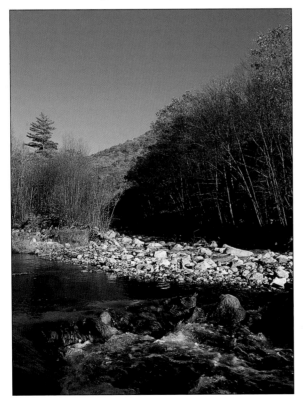

the camera via an adapter, effectively shortens the focal length (typically by a factor of 0.7x or so) and significantly widens the view of your digital camera. If you are a digital SLR user, then a wide-angle-to-short-telephoto zoom lens (18–55mm, for example, which effectively

LEFT AND FACING PAGE—When you choose a wide-angle focal length, 28mm in this case, to photograph a landscape, remember to check all parts of the scene as you compose. Fill that rectangular frame (your viewfinder or LCD screen) to create the most pleasing composition, and remember that you can turn that frame horizontally or vertically.

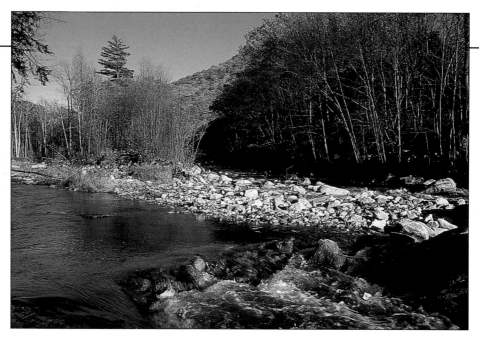

would act as approximately a 27–83mm lens) made specifically for digital cameras will likely meet your landscape photo needs.

■ FRAME THE SCENE

How should you compose a particular landscape on your camera's LCD screen or in the viewfinder? Begin by identifying what is most visually appealing to you; think about why you are drawn to this particular landscape. Then you can frame the scene to emphasize the most important landscape features. By walking to a slightly different vantage point—sometimes just a few feet away—you can often come up with a better composition. Always move around and examine the photographic possibilities.

■ PLACE THE HORIZON

Inexperienced photographers are prone to compose landscapes with the horizon halfway between the top and the bottom of the photo. You can improve the majority of your landscape photos simply by varying your placement of the horizon. You may create a better composition by placing the horizon close to the top or the bottom of the photo, or completely out of the photo. Placing the horizon high in a landscape photo emphasizes the landscape itself, while placing the horizon low emphasizes the sky and gives a greater sense of spaciousness. Consider what works best in each photographic situation.

26. LANDSCAPE PHOTOGRAPHY, PART 2

■ STRENGTHEN THE FOREGROUND

The visual significance of the foreground is often forgotten in the rush to photograph a big landscape. Use that foreground! Strengthen your landscapes by finding interesting foreground subjects. If the foreground looks weak through the viewfinder, reframe your image or move a short distance for a different perspective with a better foreground. Strong foreground elements anchor the viewer's eyes to give a greater sense of depth to a photo.

Good foreground subjects in landscape photos do not need to be large, they simply need enough visual appeal

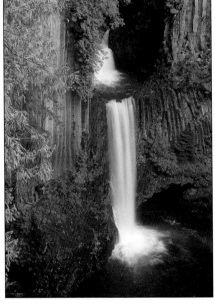

Notice how the inclusion of the nearby tree trunk gives the horizontal waterfall composition a very different feel than the vertical composition. (horizontal: 1 second @ f/27, 60mm; vertical: ½ second @ f/22, 70mm).

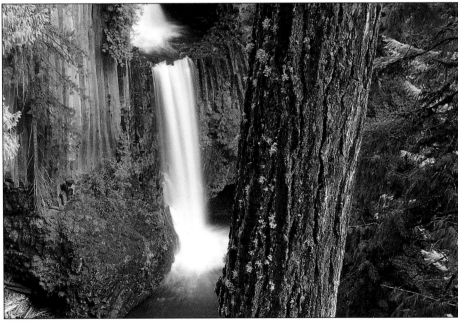

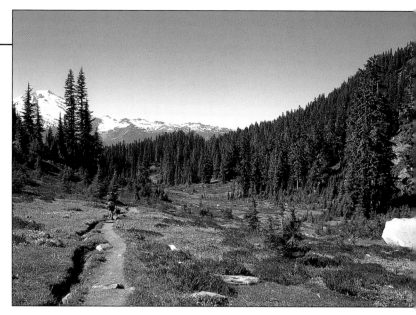

People, pets, and trails add interest to landscape images such as this wilderness scene near Mt. Baker, Washington. Notice how your eye is drawn to the snow-capped mountain, the red backpack and the whitish boulder at the far right. ($\frac{1}{125}$ second @ f/8, 28mm)

to catch the viewer's eye; this can be done with a foreground subject that has a striking texture, an unusual shape, or a bright color. You can turn average scenes into superior photos by jazzing up the foreground with eye-catching natural objects such as boulders, colorful fallen leaves, or a patch of wildflowers. Strong foregrounds are the spice of landscapes!

■ ADD A HUMAN ELEMENT

Add people to bring your landscape photos to life. People can immeasurably enhance a landscape. Even when they only occupy a tiny portion of a landscape photo, they may be very noticeable to the viewer. Candid photos of people in the landscape often work better than posed shots. If you are patient and keep your camera ready, many such opportunities will present themselves. When your subjects are moving—walking, jogging, skiing, biking—make sure you have ample shutter speed to freeze their motion. When you review your image, if the landscape is sharp but your subjects are blurred, then switch to your shutter-priority mode. Choosing a "three-digit" shutter speed ($\frac{1}{125}$, $\frac{1}{250}$, or $\frac{1}{500}$ second) will usually solve the problem.

Another consideration is the position of the people within your composition. When people are more centrally located within a scene, they will appear more prominent. Also, keep in mind the level of contrast between your subjects and the background; a red sweater will stand out in the forest far more than green clothing.

27. FORESTS AND SNOWY SCENES

■ FORESTS

Two complementary strategies for photographing forested landscapes are the "portrait" approach and the "big-picture" approach. The portrait approach is an inside view of selected features underneath the forest canopy, while the big-picture approach involves looking at the forest from the outside, that is, from above the treetops.

Portrait approach: Lines and textures are important in this portrait of an Oregon coastal rain forest. (0.7 second @ f/22, 135mm)

Big-picture approach: Autumn light combines with a recently burned forest landscape in Glacier National Park to create stark beauty. This image was composed with a moderate telephoto—135mm—focal length, which compressed the near and distant layers of green, brown and black forest. (¹/₆₀ second @ f/5.6)

For the portrait approach, choose a focal length in the short-to-moderate telephoto range (70mm to 135mm). Then pan your camera to pick out the most visually interesting subjects within a hundred feet of you. For instance, you may choose to focus on the parallel lines of tree trunks that have strikingly colored or textured bark, such as birches, aspens, or ponderosa pines. Or you may frame a forest portrait of a shaft of sunlight that brightly illuminates a patch of ferns or mushrooms within the shaded confines of the forest.

For the big-picture approach, find a vantage point with a sweeping view of the forest—typically an overlook, ridge top, or mountain summit. Then use your zoom lens to select the most visually appealing portion of the expanse before you. Pay special attention to horizon placement; to emphasize the forest, place the horizon near

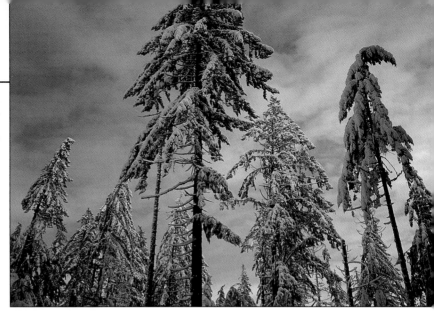

Make use of the soft light as the sky just begins to clear right after a snowstorm.

the top of the image or out of the image altogether. When you photograph a forest in hilly or mountainous terrain, try vertical compositions to show the range of elevations in the landscape.

■ SNOWY SCENES

Landscapes covered by snow or ice characteristically have pronounced textures, interesting patterns, and—if the scene is well lit—strong contrasts between light and dark. Some of the best photo opportunities are immediately after a heavy snowfall or an ice storm.

Snowy landscapes are problematic in terms of exposure. As described earlier, your camera's exposure meter works fine when the scene you are photographing is largely made up of middle tones, intermediate between black and white. In the case of a brightly sunlit, snow-covered landscape, the average tone of the landscape is far lighter than a medium gray. Consequently, photos of bright snowy landscapes often come out underexposed compared to the actual scene.

When you photograph snowy landscapes apply the previously mentioned adage, "Add light to light!" If your camera's suggested exposure turns out darker than desired, try overexposing as much as one stop or more—let experience be your guide—compared to the reading your exposure meter indicates. Many digital cameras have a "snow" (and/or "beach") scene exposure mode that does this for you. You can also photograph snowy scenes on overcast days or in low-light situations where there is less contrast in the scene and the exposure is less problematic.

28. SEASCAPES AND WETLANDS

Sometimes the simplest compositions are the best. A peaceful, sunlit sea evokes serenity.

■ SEASCAPES

There are two nearly opposite moods that landscape photographers seek to bring out when they compose seascapes. One approach is to focus on the serenity of a calm day. Look for simplicity in composition. If the horizon is visible in your composition, make certain it appears horizontal in your viewfinder; otherwise, your photo will give the odd impression that the ocean is draining downhill! Slow shutter speeds, $\frac{1}{30}$ second or longer, are useful to blur and soften the motion of waves. Use your tripod for these comparatively long exposures to prevent camera shake.

A second approach is to emphasize the dynamic tension that exists between the land and the irrepressible forces of wind, wave, and tide. This approach works well on blustery days along rocky coastlines or on stormy days at the beach. Try to record the energy of big waves as they crash into the shoreline. Look for the "decisive moment"—the climactic instant in which something with high visual appeal happens, such as a breaking wave striking a rocky headland. Make dynamic photos in which the viewer knows the scene lasted for only an instant—the particular instant you recorded!

■ WETLANDS

Marshes, swamps and bogs are excellent photo subjects. Wetlands are chock full of wildlife, particularly birds and amphibians. Be in place to photograph

within a few hours of dawn and dusk, when animals are active and slanting sunlight accents the natural beauty of wetlands.

Wetlands are characteristically flat and are usually viewed from ground level, so if you find a higher vantage point, such as a nearby hill or observation tower, you can frequently produce more interesting photos. Make good use of reflections, prominent textures, repeating patterns, and strong lines such as shorelines or boundaries between marsh and forest.

The maritime haze of a summer evening softens the collision between wave and rock. A small strip of sand in the lower left corner helps visually anchor the image. ($^1/_{125}$ second @ f/3.7, 432mm)

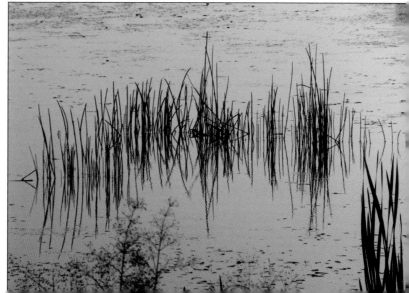

Since your mobility may be limited in wetlands, a long focal length is helpful to pick out interesting compositions. ($^1/_{1000}$ second @ f/5.6; 432mm)

29. SUN AND SKY

■ SUNRISES AND SUNSETS

An important consideration for sunrise and sunset photos is the position of the horizon. To emphasize the sun, brightly lit clouds, and the expansiveness of the sky, place the horizon low. On the other hand, if the landscape has visually appealing elements, for instance, a herd of elk or a carpet of wildflowers, then place the horizon near the top.

Sunrise and sunset exposures are tricky because of the sun's brightness and the contrast between the sky and the darker landscape. A common result is that the sky looks fine in your photo, but the land appears almost black. As in the case of photographing snowy landscapes, if you want the land to turn out closer to how your eyes see it, "add light to light." If your camera's metered exposure comes out too dark, then overexpose as much as one stop or more compared to your meter reading. The brighter the sun, and the more prominent it is in your composition, the more intentional overexposure you will

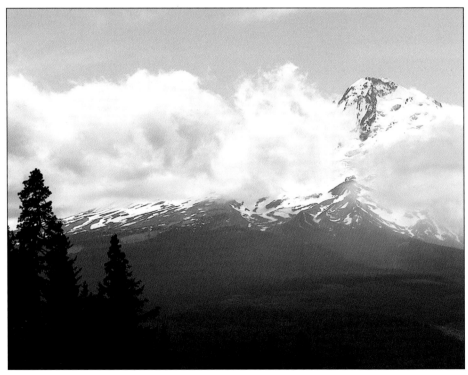

High placement of the horizon here puts greater visual emphasis on the landscape. The dark evergreens at the lower left provide balance for the mass of Mt. Hood, Oregon. (¹/₁₀₀₀ second @ f/5.6; 165mm)

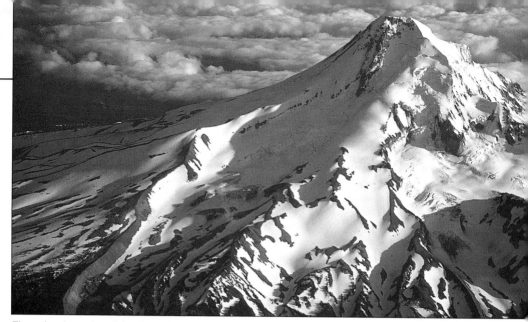

The volcanic peaks of the Cascades are terrific aerial photo subjects for travelers to the Pacific Northwest. The fact that some of them jut two miles or more into the sky puts them in perfect position to photograph.

need. Review your results to see how this increased exposure is affecting your images.

■ AERIALS

You can take excellent aerial landscape photos by following a few guidelines. If possible, fly quite early or quite late in the day to get the best light. To photograph on a commercial flight, request a window seat that is well in front of or well behind the wing. In flight you are moving very fast, so slow shutter speeds may result in blurry pictures. If you are manually setting exposures, select ¹/₂₅₀ second or faster when possible. Even if you are not manually setting exposures, you can bias your camera's exposures toward faster shutter speeds by using a medium- to high-speed ISO setting—200 or 400—or choosing a "sports" scene mode (runner icon).

For interesting photos, try to photograph at relatively low altitudes soon after take-off or shortly before landing. Line up your camera with the front element of your lens parallel to the window. Place the lens as close to the window as you can—flush is best—to avoid picking up reflections on the inside of the window. Do not use flash; it will be reflected by the window, and will surely not light up the earth! If your camera automatically activates your built-in flash, use your "flash-off" mode (typically a lightning bolt inside a circle with a slash across the bolt) to override it.

30. RUNNING AND FALLING WATER

From a location alongside a creek or river, you can make strikingly different photographs by looking upstream, downstream, and across the stream. When you are on the banks of a river with riffles or rapids, composing photos of the upstream view is frequently easiest. If a stream is flat and sluggish, you can often move from the stream bank up to a higher vantage point to find more interesting compositions. When you include a river as an element in a wide-angle landscape, use its linear form to enhance the aesthetics of the landscape; remember that curved or diagonal lines can serve as strong compositional elements.

As you photograph waterfalls, look for alternatives to the standard, head-on view. Walk around and check different perspectives through your viewfinder. You may want to zoom in or move closer and just show a portion of the falls. Make sure that the water appears to be falling vertically in your waterfall compositions, unless you desire an abstract effect.

How a waterfall appears in a photo depends on your shutter speed. If you can set them manually, use shutter speeds of $1/500$ second or faster to "freeze" the motion of falling water. Shutter speeds of $1/15$ second or slower tend to give the falling water a silky, "cotton-candy" look. The longer the exposure, the more pronounced is this silky smoothing of the falls.

If taking a long exposure is your goal, you can get there by

ABOVE AND FACING PAGE—Consider these four different perspectives of a waterfall. A traditional vertical view (60mm) of the falls (above) is complemented by a wide-angle (28mm) and a telephoto view (100mm) from beneath the falls (facing page, top and center) and a sidelong view (45mm) framed by the rock overhang (facing page, bottom). The falling water appears silky as the result of long exposures. ($1/2$ to $1 1/2$ second @ f/22 to f/32)

choosing your digital camera's lowest ISO setting—100 or less on most cameras. Then switch your camera to its aperture-priority mode, and choose the highest f-stop number (smallest aperture). This ensures that the camera will use the slowest shutter speed possible given the lighting conditions.

Finally, make sure your camera's flash is not turned on; flash would defeat your purpose by freezing the motion. If your digital camera accepts filters, you can also use a neutral density filter to reduce the light entering your camera, and thus make a longer shutter speed possible.

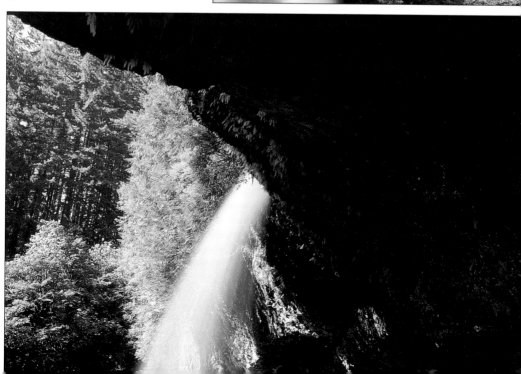

31. CLOSE-UP PHOTOGRAPHY, PART 1

The great secret to good close-up photography is—shhh, remember this is a secret—to *get close* to your photo subjects! A common beginner's mistake is to photograph flowers and other small objects from too far away. Fortunately, one of the strong suits of digital cameras—even many of the entry-level point & shoot models—is that they have superb close-focusing ability, far better than typical zoom lenses on film cameras. The lenses on most digital cameras are able to focus so close that you can get within a few inches of flowers and your other favorite close-up photo subjects. With a little practice, you can produce outstanding close-up images with your digital camera.

Just like your eyes, every photographic lens has a minimum distance at which it can focus. To take full advantage of your digital camera's close-up capabilities, you need to know what this minimum focusing distance is. Check your owner's manual (or specs available on the Web sites of camera makers and photo retailers) to find out the minimum focusing distance. Most cameras have a "macro" (i.e., close-up) mode for close-up photography; in this mode, the minimum focus distance is reduced so that you can get even closer to your subjects.

Magical worlds open up to you when you get down on the ground and move very close to small photo subjects. ($\frac{1}{60}$ second @ f/2.8, 75mm)

Note that for point & shoot and prosumer digital cameras, the minimum focusing distance is often different at the wide-angle (shorter) focal lengths than at the telephoto (longer) focal lengths. There is no particular "correct" focal length for close-up photography. As a general guideline, use the focal length(s) that allow you to position your camera so that the subject appears largest in the viewfinder or on the LCD screen.

Learn your camera's minimum focusing distance, then move in tight for wonderful close-ups. ($^1/_{125}$ second @ f/3.3, 36mm)

For example, my favorite prosumer digital camera allows me to produce the largest focused image of a flower by setting the lens between 2x (twice the minimum focal length) and 3x, whereas at longer focal lengths (for example, 5x or 10x) the minimum focusing distance is much greater, and I cannot reproduce a flower nearly as large. You learn this sort of thing by experimenting with different lens settings then reviewing your results.

You can typically tell when you are too close to focus because the steady green focus-confirmation light on your digital camera's LCD screen does not come on, or it flashes emphatically, when you depress the shutter release halfway to activate the autofocus.

The optical viewfinder on point & shoot digital cameras is separate from the lens; when you look through the viewfinder, you are not viewing through the lens as on an SLR. (This is not an issue if your camera has an electronic viewfinder.) Thus your close-up subjects may appear in focus to you through the viewfinder but may be too close for your lens to focus. Also, because of the separation of the viewfinder and lens, at very close focusing distances there is a considerable difference in the framing of the image the camera lens "sees" and the image you see through the viewfinder. If you use the viewfinder, you are looking at close-up subjects from a significantly different perspective than your lens. Review your close-up images as soon as you take them to improve the framing of your compositions.

32. CLOSE-UP PHOTOGRAPHY, PART 2

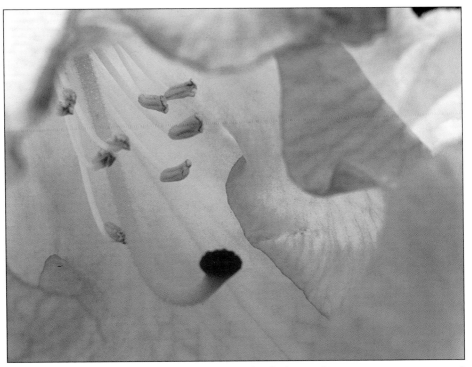

By stopping the lens down to f/8—as far as many point & shoot and prosumer cameras can go—I maximized the very limited depth of field inside this rhododendron blossom. (¹/₆₀ second @ f/8, 90mm)

■ FOCUS ON DEPTH OF FIELD

Depth of field is extremely important in close-up photography. Why? Because when you focus on subjects very close to your camera, depth of field is minimal. The closer you focus, the less depth of field you have. The zone of sharpness in an extreme close-up may only extend from a fraction of an inch in front of the subject on which you are focused to a fraction of an inch in back of the subject. For example, with a 35mm SLR camera, if you set a 100mm macro lens on f/4 and focus on a flower 2 feet away, less than ⅓ inch of the flower will be in sharp focus! As a result, accurate focusing is critical. For sharp close-up photos, follow these three guidelines:

1. Focus precisely on the most important part of your subject.
2. Make the camera as stable as possible. Use a tripod for close-up photography whenever possible.

3. Remember that you can enlarge depth of field and thus get more of your subject in focus by using a smaller aperture—that is, a higher f-stop number. In the example above, an aperture of f/22 would more than quadruple the depth of field at f/4.

■ SQUARE UP TO YOUR SUBJECTS

Given the very limited depth of field in close-up photo situations, a useful technique is to position your camera so that your lens is almost equidistant from each of the important points in your photo. To visualize this, think of aligning your camera so that the front of your lens is parallel to the most important plane (two-dimensional surface) in the close-up scene you want to photograph. This technique maximizes the amount of the image that will appear in focus.

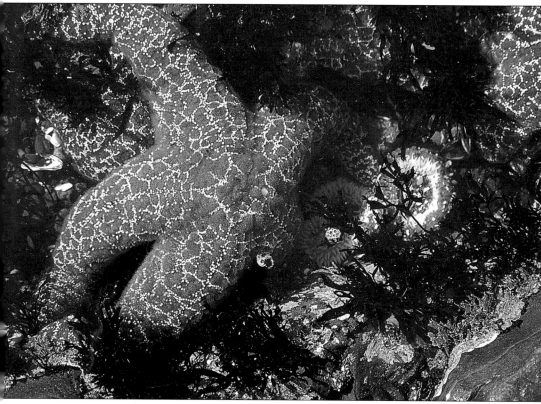

Tide pools are a great place to practice your close-up skills. A polarizing filter is useful to reduce reflections on the water's surface so that marine life will appear more clearly.

33. MACRO GEAR

If you are an avid close-up photographer, special equipment such as supplementary close-up lenses or—for digital SLR users—a macro lens may appeal to you.

A supplementary close-up lens, which many photo enthusiasts call a "diopter," is a very inexpensive accessory that reduces the minimum focusing distance of your lens. It looks like a clear filter and screws on to the front of your lens; it can be used with any digital camera that accepts screw-on filters. Supplementary close-up lenses are often sold in sets of three and have varying strengths identified as +1, +2, +3, +4, and so on. For example, a +4 will allow you to focus closer than a +3, which in turn allows you to focus closer than

BELOW AND FACING PAGE—When you find an interesting close-up subject, move in slowly and try out different perspectives as you approach. By attaching a +5 supplementary close-up lens, I was able to focus closely enough to take a photo (shown on the facing page) with the front of the lens nearly touching the beetle. Note that depth of field is limited to a fraction of an inch at this range. ($^1/_{640}$ @ f/5.6, $^1/_{500}$ @ f/4, and $^1/_{20}$ @ f/7.3; 100mm)

 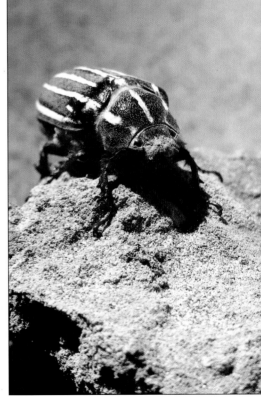

a +2. You can simultaneously attach two or more supplementary close-up lenses to your lens, which allows you to focus even closer, but doing so can noticeably degrade image quality. Use of only one supplementary close-up lens at a time is recommended, unless you absolutely must focus closer to your subject. Sets of three diopters range in price from $30 to more than $75.

If you have a digital SLR, consider a macro lens. This is a special lens for close-up photography that can focus so closely to your subjects that a single flower, a large beetle, or a small leaf may fill up an image. The most popular macro lenses have a focal length of approximately 50mm or approximately 100mm. Many professional nature photographers prefer macro lenses that are approximately 100mm, because these lenses allow greater working distance and have a narrower angle of view, which can simplify composition. Macro lenses range in price from $200 to more than $500.

Many zoom lenses for SLRs are loosely marketed as "macro zooms" but do not provide good close-focusing ability. Before you purchase a zoom lens for close-up photography, try it out and see how close it will truly focus.

34. LIGHTING FOR CLOSE-UPS

■ USE FLASH

Though most nature photography is done with ambient (naturally available) light, flash can often enhance close-up photographs. Flash is used for close-ups in situations where light levels are too low to photograph without flash. Flash is also valuable in daylight photography when used for "fill" light to brighten subjects in shaded areas of a close-up composition.

Be careful not to overpower your close-up subjects with flash; too much flash may overexpose your light-toned subjects. Many digital cameras give you the option of reducing your flash's output by whole or partial stops. In fill-flash situations, setting the flash at −1 stop (½ power) or −2 stops (¼ power) will frequently produce a more pleasing and natural-looking exposure.

Your camera owner's manual contains valuable information on various flash modes and on the effective distance range of your flash. Try out your flash modes and settings in a variety of situations with various subject-to-camera distances. Then review your images to evaluate your results.

■ CUSTOMIZE LIGHTING

The lighting for close-up photography can be enhanced in many cases with simple accessories that either reflect or diffuse ambient light. You can make reflectors by covering sheets of cardboard, from the size of an index card up to the size of a poster, with aluminum foil.

These are also useful for baking potatoes in the campfire!

Thoroughly crumple the foil—the creases in the foil will soften the reflected light—then straighten it out prior to taping or stapling it to a cardboard sheet. A simpler variation is to skip the cardboard, and just carry folded or rolled sheets of aluminum foil into the field; these are also useful for baking potatoes in the campfire! Your reflectors can be balanced in a bush or in high grass, propped against a tree trunk, or even suspended by bungee cords from low branches.

These foil reflectors are useful to bounce natural light exactly where you want it in your image. For instance, if you photograph wildflowers in a dense forest on an overcast day, minimal ambient light may reach the flowers. You can position one or more foil reflectors on the ground or in underbrush near the flowers (always making sure the reflectors are not in the image!) at an

angle such that the foil bounces light from the sky onto your photo subjects. This technique can easily double the amount of light on wildflowers.

Another good accessory to reflect light is an auto sunshade made of synthetic fabric attached to a flexible metal frame. These shades usually fold to a small size and spring open to a much larger size such as 24 x 28 inches. In addition to keeping your parked car cooler on sunny days, sunshades are also handy for nature photography! They are inexpensive (often less than $10), lightweight, durable, and come in a variety of colors and sizes. An ideal shade is silver on one side and gold on the other; the silver side provides "cool" lighting, while the gold side gives a "warmer" cast.

You can hold or prop up these shades to bounce light onto your close-up photo subjects; alternatively, you can use them to block overly bright, contrasty sunlight. An easy way to diffuse direct sunlight is to partially block the sun with a light-colored umbrella or pieces of any translucent, light-colored fabric.

Fill flash can be used to creatively adjust the lighting in many close-up images. This is a situation where digital cameras offer a huge advantage, since you can play back your images in the field for instant feedback. I often make the first image without flash, and then repeat with a couple of different flash settings. The top image is without flash, the second is with flash at ½ power (−1 stop) and the third is with flash at ¼ power (−2 stops). (¹/₁₂₅ second @ f/8, 80mm)

35. FLOWERS

To make the best of flower photo opportunities, get to know your local wildflowers. In most temperate regions, the wildflower world is a visual feast of photographic opportunities from early spring to late autumn. Also consider photo opportunities with ornamental flowers, shrubs, and blooming trees in lawns, gardens, greenhouses, and city parks.

Murphy's Law is well known to every flower photographer! More often than not, when you find beautiful flowers to photograph, a breeze is blowing and your potential photo subjects won't stand still for a picture! What's a flower photographer to do? When possible, use a triple-digit shutter speed (that is, $^1\!/_{125}$, $^1\!/_{250}$, or $^1\!/_{500}$ second) to freeze the motion of moving flowers. You can also use one or more of the following techniques to increase the probability of sharply focused flower photos in a moving-flower situation:

1. Shield the flowers from the breeze with your body, a friend, a windbreaker, or a tarp.
2. Use a higher ISO setting (200 or 400) so faster shutter speeds are possible.
3. Use one of the reflectors mentioned in lesson 34 to bounce more natural light onto the flowers, so that faster shutter speeds are possible.
4. Use your flash.

LEFT, ABOVE, AND FACING PAGE—When you find photogenic flowers, experiment with composition and lighting! A little patch of California poppies right outside my front door has provided hours of macro photo enjoyment. ($^1\!/_{100}$ second @ f/2.8, 90mm; $^1\!/_{160}$ second @ f/4, 90mm; and $^1\!/_{200}$ second @ f/8, 55mm)

5. If all else fails, be patient and wait out the breeze, or come again another day.

An easy way to enhance many flower photos is to position your camera near the ground. Setting up your camera as low as you can on your tripod, or hand-holding the camera while you lay flat on the ground, will provide a more interesting perspective. In such situations, a digital camera with an LCD screen that swivels away from the camera is a major asset, since it allows you to compose low-angle photos without putting yourself in awkward or painful positions! To create eye-catching compositions, place the camera so low that you are looking up at the flowers with the sky in the background.

■ OTHER CLOSE-UP WONDERS

The natural world is full of small objects that have appealing textures, curious patterns, and striking color combinations. Seed pods, cones, nuts, berries, tree bark, mosses, mushrooms, lichens, rocks, animal tracks, and fallen leaves make fine close-up photo subjects. The ever-changing ripple marks in the sand of dunes, beaches, and stream banks are also aesthetically enthralling. If you get close enough, you can produce wonderful images of each of these subjects!

36. WILDLIFE PHOTOGRAPHY, PART 1

■ GET TO KNOW THE ANIMALS

To successfully photograph wildlife, learn all you can about your animal photo subjects. Find out what habitats they prefer for feeding and cover. Learn their daily and seasonal activity patterns. Find out what their vocalizations and other behaviors mean. Study the acuity of their senses of sight, hearing, and smell. Find out what kinds of tracks and other signs they leave behind. And, most importantly, learn to what degree they will tolerate human intrusions, and whether your presence is potentially harmful to them—or to you!

The best way to learn about your photo subjects is to observe them in the wild. Professional nature photographers spend literally hundreds of hours closely observing the animals they photograph. A magazine cover photo often is the product of months of field photography.

■ GET TO KNOW YOUR CAMERA

In addition to a solid understanding of your photographic subjects, a thorough understanding of your digital camera is essential to your success in photographing wildlife. Use your owner's manual to find out what your camera has to offer. Your digital camera probably has a host of features that are of special value in photographing wildlife—especially rapidly moving animals. Here are a few key features to experiment with:

1. Consider using your camera's "sports" scene mode for moving wildlife; this mode biases exposures toward higher shutter speeds.
2. Try using your camera's "continuous" or "servo" autofocus mode if the distance between the animals and your camera is rapidly varying, for example, if a flock of birds is flying toward you. In continuous autofocus mode your camera keeps refocusing right up to the moment you take the photo.
3. If your shutter speeds are too slow to "freeze" the motion of moving animals in low light, then use a higher ISO setting such as 400.
4. When your have an outstanding photo opportunity—for instance, an osprey or a pelican is fishing right in front of you—and you want to take multiple images rapidly, try out your camera's "burst" mode. This mode allows your camera to briefly take an unusually speedy succession of images, typically more than one per second.

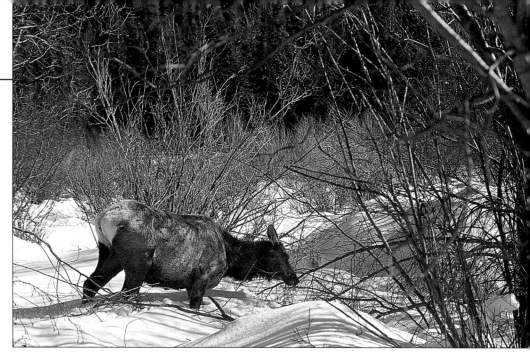

The more you learn about wildlife—and the more time you spend observing your favorite animals—the better you will become at wildlife photography. ($\frac{1}{250}$ second @ f/6.7, 90mm)

■ USE LONG LENSES

If you are passionate about wildlife photography, a lens that zooms to 300mm or more is very nice. This is where a high-end point & shoot or prosumer camera with a 10x or 12x zoom lens is an asset.

Remember that depth of field is dependent on the focal length of your lens: the longer the focal length of the lens, the shallower the depth of field. Thus precise focusing is critical when you use long telephoto focal lengths. Also, any unsteadiness of the camera is magnified at long focal lengths, so—for truly sharp photos—use a tripod whenever possible.

Many high-end digital point & shoots and prosumer cameras give you the option of using a telephoto converter lens that is designed for your particular camera. When attached to your camera, the telephoto converter lens effectively increases your focal length by a factor of 1.5x to 2x. For instance, if your camera's longest focal length is 140mm, then adding a 2x teleconverter makes your longest focal length 280mm.

Likewise, if you have a digital SLR, you can use a teleconverter that you mount between your camera and lens. There are two widely used sizes of teleconverters. A 1.4x teleconverter increases the focal length by 40 percent, and a 2x teleconverter doubles the focal length.

37. WILDLIFE PHOTOGRAPHY, PART 2

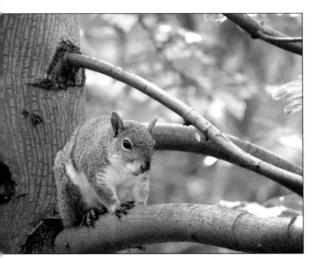

Don't overlook everyday opportunities to photograph your neighborhood wildlife. The lessons you learn while photographing your local squirrels, songbirds and rabbits will pay off when you photograph in wilder settings. ($^1/_{100}$ second @ f/2.8, 432mm)

■ PHOTOGRAPH WHERE YOU LIVE

The best of all locations to develop your wildlife photo skills is where you live. In terms of learning nature photography, there is no place like home! Photo skills you develop in your backyard or your local parks are transferable to wildlife-rich national parks and wildlife refuges. If you consistently make good photos of neighborhood squirrels and songbirds, you will have a greater chance of success when you get opportunities to photograph rare or exotic animals in wilder places.

■ PHOTOGRAPH EARLY AND LATE

More outstanding wildlife photographs are taken within a few hours of sunrise and sunset than at any other time. This is partly because so many animals are active and visible at either end of the day. The warm light and long shadows of early morning and late afternoon are also conducive to attractive photos. Conversely, the middle of the day, especially in summer, offers less interesting lighting and often less wildlife activity. Midday is an excellent time to catch up on the sleep you missed when you rose to photograph animals at dawn!

■ BE PATIENT

Take your time! Every wildlife photographer quickly learns that nature is not a vending machine; you cannot make wildlife appear or pose on command. Not surprisingly, nature always moves at a natural pace, and great wildlife photography takes great patience. To find and photograph the truly extraordinary moments in nature takes a lot of time. Wonderful opportunities are available to the photographer who is in the right place at the right time. You simply have to be there!

■ FEED WILDLIFE?

To feed wildlife for the sake of attracting animals to photograph is a very bad idea, with the sole exception of a permanent, well-maintained backyard bird feeding station. Baiting wild animals, particularly in residential and park areas, has detrimental consequences:

1. The animals develop an increased dependence on people for food, along with a markedly decreased ability to survive in the wild.
2. Animals that live on human food can become malnourished. This is frequently the case with ducks and geese that subsist on human hand-outs in municipal park ponds, rather than on a far more nutritious natural diet.
3. Wild animals that learn to get food from humans often exhibit aggressive behavior toward pets and people with unfortunate results. "Pan-handling" animals that hang around in backyards and city parks can also carry serious diseases such as rabies.

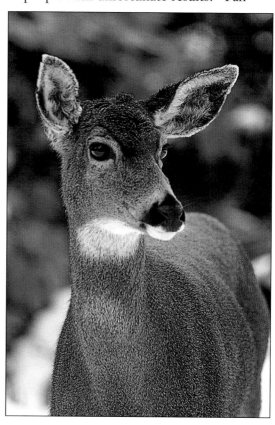

Please remember that wild animals by definition are not domesticated animals. Rely on your knowledge of animals and your patience—not on potato chips and a moldy loaf of bread—to get those superb wildlife photos!

While photographing this deer in the low light of an overcast January afternoon, I opened the aperture to f/4 to get the fastest shutter speed I could. Any time you are photographing animals at relatively slow shutter speeds, take at least several photos to increase your odds of a sharp exposure. (1/60 second, 250mm)

38. MAMMALS

■ LARGE MAMMALS

To judge by how frequently various types of wildlife appear on the covers of magazines and coffee-table photo books, large mammals such as deer, elk, bears, and bighorn sheep are among the most popular photo subjects. Two inherent advantages of photographing large mammals are that the animals are big enough that you do not have to be exceptionally close to photograph them, and you do not necessarily need a long telephoto lens for a good photo.

One preferred feature of a good photo of a large mammal is that at least one of the animal's eyes is readily visible and in sharp focus. Why? Because when we see a large animal in real life or in a photo, we immediately look to the animal's eyes, similar to the way we establish eye contact with other people. So try to always get an unobstructed view of at least one eye. A well-lit eye is preferable to one in deep shade. This is an ideal situation in which to use the pre-focusing technique explained earlier in lesson 23.

When you photograph large mammals, reach beyond the cliché of animal portraits that appear to be posed, with a wary-looking animal standing stiffly at attention. Strive for candid wildlife photos in which the animals exhibit their normal behavior rather than a reaction to a noisy photographer. If the animals are aware of your presence, then be absolutely still, and allow plenty of time—preferably hours, if not days—for them to become accustomed to you. Given time, many animals will ascertain that you are not a threat, and they will resume their everyday behavior.

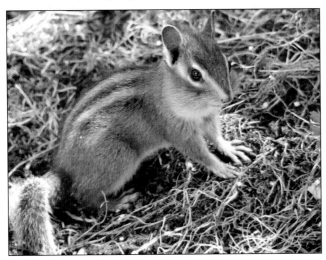

LEFT AND FACING PAGE—How do you photograph a harbor seal or a chipmunk? Preferably, at seal level or chipmunk level. A low camera position enhances the apparent size of animals in your photos, and you may also find that animals will feel safe to approach much closer to you and your camera if you are on their level. (chipmunk: $\frac{1}{40}$ second @ f/2.8, 432mm)

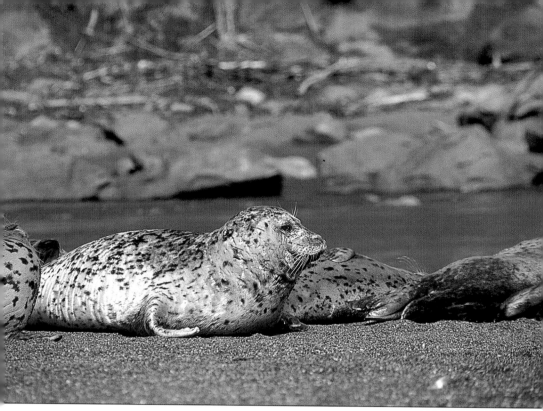

■ SMALL MAMMALS

Small, furry creatures—including squirrels, rabbits, groundhogs, and chipmunks—are frequently present in residential areas and local parks. Many of them are surprisingly approachable and even gregarious around nature photographers. Keep in mind that these animals often appear even smaller than you anticipate in your photos. Use the long (telephoto) end of your zoom range for maximum magnification. You can also accentuate the apparent size of small mammals by photographing them from a very low camera position.

One of the pronounced traits of many small mammals is that they must move quickly to escape predators. If they feel threatened by your approach, they will immediately run to dense cover, dive in a nearby burrow, or climb a tree far out of reach. Thus you need to learn the "safety distance" of each species; in other words, how close you can be before the animal will react by moving to safety. You will get many of your best photos by photographing from just beyond that distance.

To freeze the rapid motion of small mammals often requires shutter speeds of $1/125$ second or faster; this depends on the animal's speed, your focal length, and how close you are to the animal. Use higher ISO settings—200 or 400—to make faster shutter speeds available in low-light situations.

39. BIG BIRDS

■ BIRDS OF PREY

The wildness, grace, size, and sheer power of eagles, hawks, falcons, and owls make them favorites of wildlife photographers. Fortunately for photographers, many birds of prey characteristically spend much of their time perching almost motionless as they carefully survey their surroundings. For good photos of raptors, get as close as you can without disturbing the bird. How close? This depends on the species, the time of year, the habitat, and the individual bird's previous experience with people. Keep in

One of the creative joys of digital photography is using image-editing software to crop images and produce formats that suit individual images. ($1/800$ second @ f/8, 432mm)

mind that birds of prey are protected under federal law and that many raptors such as the bald eagle are easily disturbed during the nesting season.

Birds of prey have very regular patterns of hunting and fishing behavior. For example, kestrels hover like feathered helicopters for minutes at a time over grassy areas as they hunt small rodents, and ospreys circle lazily over open water before diving for fish. Once you learn these behavioral patterns, you can position yourself to capture the high-speed interactions between raptors and their prey.

■ WATERFOWL

Four factors favor waterfowl as photo subjects: their comparatively large size, their large populations, their tendency to congregate in large groups, and their tolerance of the large human presence in many parks and refuges. When photographing waterfowl, nature photographers often use blinds to conceal their presence. A blind is a temporary or permanent camouflaged structure large enough for one or several photographers. Refuges sometimes have permanent blinds set up for observation. You can also park near wetlands in many refuges and use your vehicle as a blind; many animals are far less wary of a car or a truck than of a person on foot.

To develop your waterfowl photo skills, you might first photograph slow-moving birds floating on the water. Also practice following the birds in flight

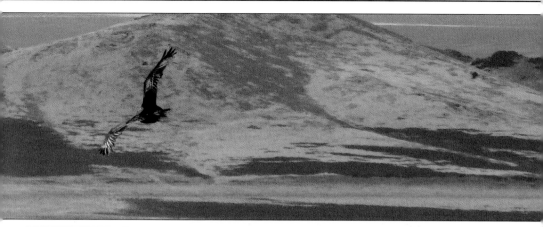

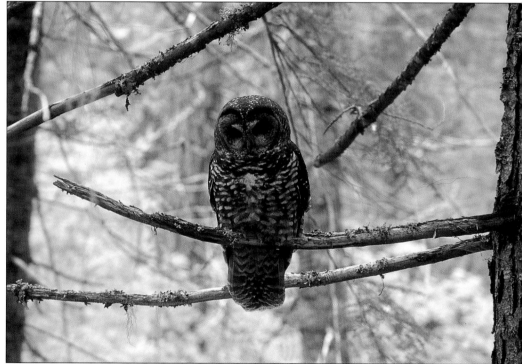

To photograph uncommon wildlife, such as the threatened spotted owl of the Pacific Northwest's old-growth forests, requires patience, perseverance, and special care that as a photographer you do not become another stress on the animals you photograph. (200mm)

through your camera's viewfinder or on the LCD screen. Learn to anticipate the timing and direction of explosive waterfowl take-offs and photogenic group landings.

40. BACKYARD CRITTERS

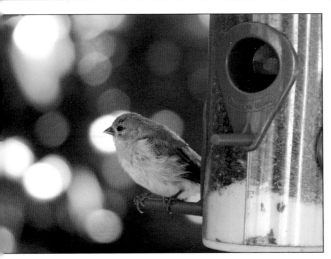

Small birds make a lot of quick movements that can foil attempts at sharply focused photos. In this situation, an ISO setting of 200—with the lens wide open at f/2.8—yielded a just-fast-enough shutter speed of ¹⁄₆₀ second. Fifteen exposures of this little finch during a birdfeeder photo session produced some nice results. (432mm)

■ SONGBIRDS

Virtually anywhere people live, from large cities to suburbs to small towns, backyard birds can be found. To improve your photo opportunities, enhance your backyard habitat for songbirds. Techniques range from simply providing a bird feeder, to putting up nest boxes, or landscaping with native shrubs and trees that provide food and cover. Songbirds are very small, so use the longest focal length you have and get as close as possible! Use higher ISO settings—200 or 400—to freeze the rapid movements of small birds.

Many backyard bird photos, especially snowy winter portraits, are taken from indoors. You can take excellent bird photos through a living room window. Make sure the window is clean, put the camera very close to the window, line up the camera so that the front of the lens is parallel to the window, and turn off indoor lights to reduce reflections. Do not use your flash; the light from a flash would be reflected in the window and would dominate the photo. Depending on the traffic flow inside your home, you might even leave a camera set up on a tripod with a clear view of a backyard bird feeder. This increases the chances you will be ready when good photo opportunities arise.

■ ITSY-BITSY CREATURES

Excellent small photo subjects include frogs, lizards, butterflies, moths, spiders, snakes, ants, bees, caterpillars, and even slugs! These little creatures are among the most photogenic denizens of the natural world; they often display brilliant coloration, striking patterns, or intricate camouflage. These small wonders are accessible in local parks and backyards—too accessible, it seems, when you find them living in your house!

ABOVE—There's more than one way to photograph a wasp. Look for unusual approaches to everyday subjects. What you see is the shadow of a wasp that was standing on a maple leaf; the view is from beneath the leaf. ($^1/_{640}$ second @ f/5.6, 95mm)

RIGHT—Take your time to move in close enough for portraits of small creatures. Go beyond simply focusing on the animal, and consider the whole composition. Diagonal lines play a key role in this particular image. ($^1/_{15}$ second @ f/2.8, 120mm)

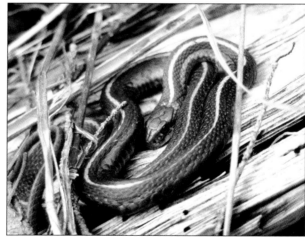

An overriding concern for successful photography of very small animals is to get extremely close to them—often as close as your lens allows. A good strategy is to start 8 to 10 feet away from little creatures, then very slowly creep closer. Use the longest focal length of your zoom lens for maximum magnification, unless a shorter focal length will give you much closer minimum focusing distance. Stay as low to the ground as possible to make these small animals appear larger.

CLOSING THOUGHTS

Becoming a better nature photographer is a lifelong process; the deep enjoyment that nature photography brings also lasts a lifetime. The forty lessons in this volume have hopefully increased your confidence in your ability to produce images you will treasure. If you apply one lesson each time you photograph, that's progress.

The next time you see a beautiful landscape, a profusion of wildflowers, or photogenic wildlife, slow down, take a deep breath, and then savor every moment of creating quality images. Return to these pages when needed for review, to answer questions that arise, or for inspiration when the creative doldrums come to call.

Digital cameras are getting better all the time. These tiny wonders give you everything you need to make consistently excellent photos. The instant feedback provided by digital cameras is in itself a major advance in photographic technology for each of us to learn from. Get outdoors and use your creative talents to craft nature images that you will share and enjoy for many years to come. Make the best of these wonderful tools.

Happy trails!

Aperture—The diameter of the lens opening through which light passes to reach the image sensor. Apertures are commonly expressed as f-stops.

Autofocus (AF)—An electronic system that automatically focuses the lens.

Blind—A camouflaged structure that conceals a photographer and makes it possible to unobtrusively observe and photograph wildlife.

Bracketing—The technique of taking two or more exposures—with slightly different exposure settings—of the same scene. This is usually done by taking an exposure at the metered exposure setting, then taking additional exposures at other settings varying from one another by half or full stops. Bracketing is used in difficult or unusual exposure situations.

Composition—The arrangement of the artistic elements (shape, form, color, tone, pattern, texture, balance, and perspective) that make up a photo.

Depth of field—In a photograph, the zone from near to far that appears in acceptably sharp focus. Depth of field depends on the focal length of the lens, the lens aperture (f-stop), and the distance at which the lens is focused.

Depth-of-field preview—A feature on some digital SLR cameras that lets the photographer preview in the viewfinder the front-to-back zone of sharpness as it will appear in an image.

Digital SLR (single-lens-reflex) camera—A digital camera with an optical viewfinder that allows you to look through the lens. Lenses can be interchanged on digital SLRs.

Exposure—The amount of light that reaches the image sensor. Exposure is determined by the duration and intensity of light striking the image sensor; these two variables are controlled by the shutter speed and aperture respectively.

Exposure compensation—A feature that allows you to purposely underexpose or overexpose images compared to the camera's metered exposure.

Exposure meter—A light-measuring device in the camera that determines how much light is reflected from the photographic subject and thus how to expose the image. Also known as a "light meter" or simply "meter." As a verb, "meter" refers to pointing your camera toward a subject to measure or "read" how much light is reflected from it.

Filter—A supplementary lens attachment designed to enhance photos.

Focal length—The distance from the optical center of a lens to the image sensor, measured in millimeters; this is the usual way of identifying lenses.

Focus lock—A common feature on digital cameras; when you push the shutter release down approximately halfway, the camera autofocuses and remains focused at the same distance until you take your finger off the shutter release. This technique does not work if the camera is set on "continuous autofocus" or "servo autofocus" mode.

f-stop—The standard way of expressing the lens aperture (the diameter of the lens opening); f-stops include f/2.8, f/4, f/5.6, f/8, f/11, f/16, and f/22, where "f" represents the focal length of the lens. Thus, f/2.8 is a comparatively large lens opening; f/22 is a very small lens opening.

Histogram—A graph that shows frequency distribution of tones within a digital image. An exposure histogram may be displayed on the LCD screens of some cameras, or in some image-editing software when the image is viewed on a computer.

ISO—The standard measure of an image sensor's (or a photographic film's) sensitivity to light.

JPEG—An acronym for "Joint Photographic Experts Group"; this is the most common file format for recording photos with consumer digital cameras.

LCD screen—A small liquid crystal display monitor on the back of a digital camera that is used to preview and/or review images, and to set camera functions via menus.

Lens speed—The largest aperture of a particular lens.

Live histogram—An exposure histogram that can be previewed prior to recording an image on some prosumer and high-end point & shoot digital cameras.

Macro lens—A lens designed especially for close-up photography. It can be focused at photographic subjects very close to the camera.

Megapixel—One million picture elements ("pixels"), the standard unit of measure of the resolution of a digital camera's image sensor.

Minimum focusing distance—The shortest camera-to-subject distance at which a particular lens is capable of focusing.

Oops—What a photographer says immediately after taking an accidental photo of his or her foot. This is a situation in which digital cameras are far preferable to film cameras because mistakes are free—no film and processing to pay for—and you can immediately delete the image.

Overexposure—An image or a portion of an image that is too light ("washed

out" or "blown out") because the image sensor was exposed to too much light.

Point & shoot digital camera—A lightweight, compact digital camera that has a built-in lens and that automatically focuses and sets exposures.

Polarizing filter—A filter that reduces reflections from shiny surfaces, enhances color saturation, and deepens blue skies.

Prosumer digital camera—A sophisticated digital camera that is—in terms of size, price, and features—usually intermediate between a point & shoot digital camera and a digital SLR.

Rule of thirds—A guideline for photo composition that suggests visualizing your viewfinder or LCD screen divided into thirds, then placing the main subject(s) of an image near the intersections of these "thirds" lines.

Self-timer—A delayed exposure feature; you push the shutter release and 10 seconds (or some other measured time interval) later the camera takes a photo.

Shutter speed—The amount of time that the camera's shutter is open during an exposure to allow light to reach the image sensor.

Spot meter—A type of exposure meter, built into most digital cameras, that evaluates the light reflected from a small area—a "spot"—in the center of the image as seen through the viewfinder.

Stop—The increments between each of the standard shutter speeds and between each of the standard apertures (f-stops). Changing either the shutter speed or the aperture by one stop either doubles or cuts in half the amount of light that reaches the image sensor during an exposure.

Supplementary close-up lens—A filter-like accessory that screws onto the front of a lens and reduces the minimum focusing distance of the lens, thus allowing the photographer to take photos closer to subjects.

Telephoto lens—A lens with a focal length significantly longer than 50mm.

35mm—The most common format for film photography; each frame of film is approximately 35mm long.

Underexposure—An image or a portion of an image that is too dark ("blocked up") because the image sensor was not exposed to enough light.

White balance—A setting on a digital camera to calibrate the image sensor to produce a photo with accurate colors in particular lighting conditions.

Wide-angle lens—A lens with a focal length significantly shorter than 50mm.

Zoom lens—A lens that can be adjusted to a range of different focal lengths.

ABOUT THE AUTHOR

Cub Kahn is a nature photographer, writer, and environmental educator based in the foothills of Oregon's Coast Range. He has taught outdoor photography for 20 years, and his photos have appeared in numerous publications including *Audubon, Backpacker, National Wildlife, Sierra,* and *The New York Times.* He is the author of *Essential Skills for Nature Photography* and *The Art of Photographing Water,* also published by Amherst Media. His photography focuses on the landscapes and ecology of mountains, rivers and coastlines. He teaches geography at Oregon State University.

INDEX

THE MASTER GUIDE FOR WILDLIFE PHOTOGRAPHERS

Bill Silliker, Jr.

How do professional nature photographers capture those picture-postcard images of elusive animals? In this book, you'll discover the techniques you need to get close to your subjects (such as calling and tracking) and how to ensure the best possible image once you have an animal in sight. Includes safety tips for wildlife photo shoots. $29.95 list, 8½x11, 128p, 100 color photos, index, order no. 1768.

THE BEST OF NATURE PHOTOGRAPHY

Jenni Bidner and Meleda Wegner

Legends like Jim Zuckerman and John Sexton share the secrets of their trade—and engaging stories from nature photography shoots around the globe. Packed with techniques for all genres of nature photography—from panoramic landscapes to super-macro images of insects—this book lets you follow in the footsteps of top photographers as they capture the beauty and drama of nature. $29.95 list, 8½x11, 128p, 150 color photos, order no. 1744.

THE DIGITAL DARKROOM GUIDE WITH ADOBE® PHOTOSHOP®

Maurice Hamilton

Once you've taken some great digital images, the next challenge is to turn them into top-quality prints. In this book, you'll learn how to bring the control of the photographic darkroom to your desktop. Following along with the screen shots and step-by-step instructions, you'll quickly learn how to create flawless fine-art prints. $29.95 list, 8½x11, 128p, 140 color images, index, order no. 1775.